Adversarial Design

Design Thinking, Design Theory
Ken Friedman and Erik Stolterman, editors

Design Things, A. Telier (Thomas Binder, Pelle Ehn, Giorgio De Michelis, Giulio Jacucci, Per Linde, and Ina Wagner), 2011

Adversarial Design, Carl DiSalvo, 2012

China's Design Revolution, Lorraine Justice, 2012

Adversarial Design

Carl DiSalvo

The MIT Press
Cambridge, Massachusetts
London, England

First MIT Press paperback edition, 2015

MIT Press books may be purchased at special quantity discounts for business or sales promotional use. For information, please email special_sales@mitpress.mit.edu.

This book was set in Stone Sans and Stone Serif by Toppan Best-set Premedia Limited. Printed and bound in the United States of America.

Library of Congress Cataloging-in-Publication Data

DiSalvo, Carl, 1971–
Adversarial design / Carl DiSalvo.
 p. cm. — (Design thinking, design theory)
Includes bibliographical references and index.
ISBN 978-0-262-01738-1 (hardcover : alk. paper) — 978-0-262-52822-1 (pb.)
1. Design—Political aspects. I. Title.
NK1520.D57 2012
745.4—dc23
 2011039218

10 9 8 7 6 5 4 3 2

This book is dedicated to Betsy.

Contents

Series Foreword

As professions go, design is relatively young. But the practice of design predates professions. In fact, the practice of design—making things to serve a useful goal, making tools—predates the human race. Making tools is one of the attributes that made us human in the first place.

Design, in the most generic sense of the word, began over 2.5 million years ago when *Homo habilis* manufactured the first tools. Human beings were designing well before we began to walk upright. Four hundred thousand years ago, we began to manufacture spears. By forty thousand years ago, we had moved on to specialized tools.

Urban design and architecture came along ten thousand years ago in Mesopotamia. Interior architecture and furniture design probably emerged with them. It was another five thousand years before graphic design and typography got their start in Sumeria with the development of cuneiform. After that, things picked up speed.

All goods and services are designed. The urge to design—to consider a situation, imagine a better situation, and act to create that improved situation—goes back to our prehuman ancestors. Making tools helped us to become what we are, and design helped to make us human.

Today, the word *design* means many things. The common factor linking them is service, and designers are engaged in a service profession in which the results of their work meet human needs.

Design is first of all a process. The word *design* entered the English language in the 1500s as a verb, with the first written citation of the verb dated to 1548. *Merriam-Webster's Collegiate Dictionary* defines the verb *design* as "to conceive and plan out in the mind; to have as a specific purpose; to devise for a specific function or end." Related to these is drawing, with an emphasis on drawing a plan or map, as well as "to draw plans for; to create, fashion, execute or construct according to plan."

Half a century later, the word began to be used as a noun, with the first cited use of the noun *design* occurring in 1588. *Merriam-Webster's* defines the noun as "a particular purpose held in view by an individual or group; deliberate, purposive planning; a mental project or scheme in which means to an end are laid down." Here, too, purpose and planning toward desired outcomes are central. Among these are "a preliminary sketch or outline showing the main features of something to be executed; an underlying scheme that governs functioning, developing or unfolding; a plan or protocol for carrying out or accomplishing something; the arrangement of elements or details in a product or work of art." Today, we design large, complex processes, systems, and services, and we design organizations and structures to produce them. Design has changed considerably since our remote ancestors made the first stone tools.

At a highly abstract level, Herbert Simon's definition covers nearly all imaginable instances of design. To design, Simon writes in *The Sciences of the Artificial* (1996, 111), is to "[devise] courses of action aimed at changing existing situations into preferred ones." Design, properly defined, is the entire process across the full range of domains required for any given outcome.

But the design process is always more than a general, abstract way of working. Design takes concrete form in the work of the service professions that meet human needs, a broad range of making and planning disciplines. These include industrial design, graphic design, textile design, furniture design, information design, process design, product design, interaction design, transportation design, educational design, systems design, urban design, design leadership, and design management, as well as architecture, engineering, information technology, and computer science.

These fields focus on different subjects and objects. They have distinct traditions, methods, and vocabularies that are used and put into practice by distinct and often dissimilar professional groups. Although the traditions dividing these groups are distinct, common boundaries sometimes form a border. Where this happens, they serve as meeting points where common concerns build bridges. Today, ten challenges uniting the design professions form such a set of common concerns.

Three performance challenges, four substantive challenges, and three contextual challenges bind the design disciplines and professions together as a common field. The performance challenges arise because all design professions

1. act on the physical world;
2. address human needs; and

3. generate the built environment.

In the past, these common attributes were not sufficient to transcend the boundaries of tradition. Today, objective changes in the larger world give rise to four substantive challenges that are driving convergence in design practice and research. These substantive challenges are

1. increasingly ambiguous boundaries between artifacts, structure, and process;
2. increasingly large-scale social, economic, and industrial frames;
3. an increasingly complex environment of needs, requirements, and constraints; and
4. information content that often exceeds the value of physical substance.

These challenges require new frameworks of theory and research that address contemporary problem areas while helping designers solve specific cases and problems. In professional design practice, we often find that solving design problems requires interdisciplinary teams with a transdisciplinary focus. Fifty years ago, a sole practitioner and an assistant or two could solve most design problems. Today we need groups of people with skills across several disciplines, including the skills that enable professionals to work with, listen to, and learn from each other as they solve problems.

Three contextual challenges define the nature of many design problems today. These issues affect many of the major design problems that challenge us, but they also affect simple design problems linked to complex social, mechanical, or technical systems. These issues are

1. a complex environment in which many projects or products cross the boundaries of several organizations, stakeholder, producer, and user groups;
2. projects or products that must meet the expectations of many organizations, stakeholders, producers, and users; and
3. demands at every level of production, distribution, reception, and control.

These ten challenges require a qualitatively different approach to professional design practice than was the case in earlier times. Past environments were simpler. They made simpler demands. Individual experience and personal development were sufficient for depth and substance in professional practice. Although experience and development are still necessary, they are no longer sufficient. Most of today's design challenges require analytic and synthetic planning skills that cannot be developed through practice alone.

Professional design practice today involves advanced knowledge. This knowledge is not solely a higher level of professional practice. It is also a qualitatively different form of professional practice that emerges in response to the demands of the information society and the knowledge economy to which it gives rise.

In a recent essay, Donald Norman challenges the premises and practices of the design profession. In the past, designers operated on the belief that talent and a willingness to jump into problems with both feet gave them an edge in solving problems. Norman (2010) writes:

In the early days of industrial design, the work was primarily focused upon physical products. Today, however, designers work on organizational structure and social problems, on interaction, service, and experience design. Many problems involve complex social and political issues. As a result, designers have become applied behavioral scientists, but they are woefully undereducated for the task. Designers often fail to understand the complexity of the issues and the depth of knowledge already known. They claim that fresh eyes can produce novel solutions, but then they wonder why these solutions are seldom implemented, or if implemented, why they fail. Fresh eyes can indeed produce insightful results, but the eyes must also be educated and knowledgeable. Designers often lack the requisite understanding. Design schools do not train students about these complex issues, about the inter-locking complexities of human and social behavior, about the behavioral sciences, technology, and business. There is little or no training in science, the scientific method, and experimental design.

This is not industrial design in the sense of designing products, but industry-related design—design as thought and action for solving problems and imagining new futures. This new MIT Press series of books emphasizes strategic design to create value through innovative products and services, and it emphasizes design as service through rigorous creativity, critical inquiry, and an ethics of respectful design. This rests on a sense of understanding, empathy, and appreciation for people, for nature, and for the world we shape through design. Our goal as editors is to develop a series of vital conversations that help designers and researchers to serve business, industry, and the public sector for positive social and economic outcomes.

We will present books that bring a new sense of inquiry to the design, helping to shape a more reflective and stable design discipline able to support a stronger profession grounded in empirical research, generative concepts, and the solid theory that gives rise to what W. Edwards Deming (1993) described as profound knowledge. For Deming, a physicist, engineer, and designer, profound knowledge comprised systems thinking and

the understanding of processes embedded in systems; an understanding of variation and the tools we need to understand variation; a theory of knowledge; and a foundation in human psychology. This is the beginning of "deep design"—the union of deep practice with robust intellectual inquiry.

A series on design thinking and theory faces the same challenges that we face as a profession. On one level, design is a general human process that we use to understand and to shape our world. Nevertheless, we cannot address this process or the world in its general, abstract form. Rather, we meet the challenges of design in specific challenges, addressing problems or ideas in a situated context. The challenges we face as designers today are as diverse as the problems clients bring us. We are involved in design for economic anchors, economic continuity, and economic growth. We design for urban needs and rural needs and for social development and creative communities. We are involved with environmental sustainability and economic policy, agriculture competitive crafts for export, competitive products and brands for micro-enterprises, developing new products for bottom-of-pyramid markets and redeveloping old products for mature or wealthy markets. Within the framework of design, we are also challenged to design for extreme situations, for biotech, nanotech, and new materials, and design for social business, as well as conceptual challenges for worlds that do not yet exist such as the world beyond the Kurzweil singularity— and for new visions of the world that does exist.

The Design Thinking, Design Theory series from the MIT Press will explore these issues and more—meeting them, examining them, and helping designers to address them.

Join us in this journey.

Ken Friedman
Erik Stolterman
Editors, Design Thinking, Design Theory Series

Acknowledgments

I have been thinking about the political qualities and potentials of technology, design, and art for over a decade, and hundreds of conversations among friends and colleagues have informed this book. Special thanks go to Nathan Martin for the years of working together on these topics. My friend Hans Meyer was the most instrumental of all in the development of these ideas and also their harshest critic. He is missed, and his nagging skepticism has helped keep my claims in check. Dick Buchanan, Jodi Forlizzi, Judith Model, and Illah Nourbakhsh provided me with discipline and fortitude as a graduate student, and years later, what they taught me remains invaluable. This book would not have been completed without the support of my colleagues at the Georgia Institute of Technology. In particular, I am grateful for the guidance provided by Janet Murray, who patiently read these chapters many times and provided me with a wealth of feedback and encouragement. I am also indebted to Ian Bogost for his mentorship and friendship. In addition, I am thankful for fruitful discussions with my colleagues Jay Bolter, Hugh Crawford, Michael Nitsche, Anne Pollack, and Eugene Thacker. Many others have provided feedback to the ideas in this book, sometimes unwittingly, and I thank Emily Bates, Steve Dietz, Francine Gemeperle, Ian Hargraves, Tad Hirsh, David Holstius, Sabine Junginer, Jon Kolko, Victor Margolin, Phoebe Sengers, Peter Scupelli, Liz Thomas, and Cristen Torrey for the conversations we have had. Cinqué Hicks provided enormous editorial feedback and support throughout this process. My family made this book possible. Special thanks go to Carl Frost. My mother and father, Susan and Joseph DiSalvo, taught me the value of contestation and instilled in me an appreciation for the arts and scholarship. And above all, thanks to Betsy, Evy, and Josie for their unwavering support.

1 Design and Agonism

On a spring day in 2002, a half dozen or so toy robot dogs ambled awkwardly across an overgrown lot, the site of a former glass manufacturing plant in the Bronx, New York. Their translucent plastic bodies rolled back and forth on wheels that were attached in the sockets that once held their translucent plastic legs (figure 1.1). Several young people stood watching. These robot dogs had a purpose, and their movements were meaningful. They were on the hunt, released in a pack to sniff out toxic residue in the environment (figure 1.2).

When one thinks of using robots or other advanced technologies for environmental monitoring, most probably imagine trained professionals using sophisticated and expensive equipment. But these presumptions about the practices of science and engineering are being challenged by Natalie Jeremijenko (2002–present) in the *Feral Robotic Dogs* project. For this project, Jeremijenko hacks toy robot dogs, augmenting them with wheels and sensors so that they can be used as low-fidelity mobile pollution detectors.[1] Working with others, she releases these hacked robot dogs to find exposure risks in selected areas, and each release becomes a media event that draws attention to the concerns of detecting and acting on toxicity in our everyday surroundings. Through the *Feral Robotic Dogs* project, Jeremijenko demonstrates the possibilities of creatively appropriating technology toward new ends and engaging the public in political issues through compelling technological things. In addition to being tools, these hacked robot dogs are also platforms through which to question, contest, and reframe notions of expertise in technology use and environmental monitoring.

The *Feral Robotic Dogs* project exemplifies a kind of cultural production that I call *adversarial design*. This work straddles the boundaries of design and art, engineering and computer science, agitprop and consumer products. It spans a range of audiences and potential users and falls under

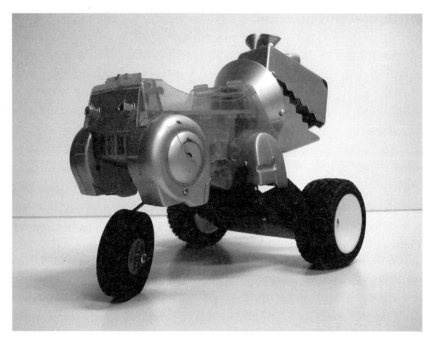

Figure 1.1
A modified robot dog, Natalie Jeremijenko, *Feral Robotic Dogs* project (2002)

various labels, such as critical design and tactical media.[2] But across the differences, there is a common characteristic. Through designerly means and forms, adversarial design evokes and engages political issues. Adversarial design is a type of political design.

It is easy to make claims about the political qualities and potentials of design, but those claims need a warrant and a means of extending those claims across multiple objects and practices. Specificity is needed regarding the kinds of politics at play and the ways that designerly means and forms do what they do. I use the phrase *adversarial design* to label works that express or enable a particular political perspective known as *agonism*. And I do not limit the term *design* to the profession of design but rather extend it across disciplinary boundaries to include a range of practices concerned with the construction of our visual and material environments, including objects, interfaces, networks, spaces, and events. Adversarial design is a kind of cultural production that does the work of agonism through the conceptualization and making of products and services and our experiences with them.

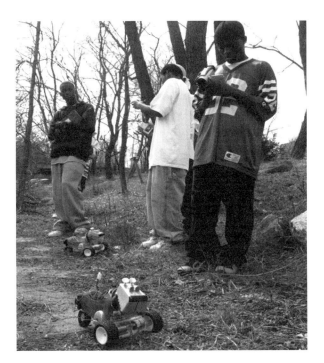

Figure 1.2
The Bronx, New York, release of dog robots, Natalie Jeremijenko, *Feral Robotic Dogs* project (2002)

But do we really need another way to talk about design and about what design can and could do? Regarding design, politics, and the political, I argue yes. Since the turn of the twenty-first century, there has been an increased interest in how the practices and products of design shape and contribute to public discourse and civic life. Evidence of this can be found in a host of conferences and conference themes, trade publications, and reports promoting so-called social design, design for democracy, social innovation, and the like.[3] Much of this work is oriented toward improving the mechanisms of governance and increasing participation in processes of governance: it is design for politics. And much of it works through familiar forms of civic engagement and of design. But not all contemporary design work fits neatly into such forms. Jeremijenko's *Feral Robotic Dogs* is a case in point. It is certainly about participation but not through standard means. And its agenda and its politics are more about a subtle, playful contestation than about consensus. How do we make sense of such projects? How do they contribute to shaping society? This book attempts to

provide an answer to these questions by exploring how political theory, design, and technology might be woven together to create unique opportunities for new forms of political expression and action. Agonism, as a political theory, provides a productive starting point for exploring this question because theories of agonism assert that there are important differences between politics and the political and that democratic civic life and public discourse are grounded in the kind of contestation that characterizes adversarial design.

Agonism in Theory and Design

Taking its title from a chant used by protestors, the documentary *This Is What Democracy Looks Like* captured the 1999 World Trade Organization (WTO) demonstrations in Seattle, Washington, combining video footage from over a hundred individuals with narrations from participants (Friedberg and Rowley 2000). During these demonstrations, thousands of people—including members of labor unions, school teachers, and environmental activists—gathered in the streets of Seattle to oppose the policies of the WTO. The varied forms of demonstrations reflected the varied positions of the people who participated. Some groups organized marches and carried signs, others performed theater in the streets and drum circles in parks, and some engaged in civil disobedience. To declare that such a cacophony of voices and actions "is what democracy looks like" is bold and, to many, confusing and alarming. Such scenes run counter to North American ideas about democracy, which is exemplified by town meetings, party caucuses, and elections. But this chant declares that democracy is not simply order and rationality displayed in voting, structured decision making, and legislating, but that it also and *necessarily* is contentious affect and expression.

Within political theory, the notions of *agonism* and *agonistic pluralism* provide grounding for the idea of democracy as intrinsically contentious and thereby also provide a basis for understanding adversarial design and what it means to talk about design doing the work of agonism. Agonism is a condition of disagreement and confrontation—a condition of contestation and dissensus. Those who espouse an agonistic approach to democracy encourage contestation and dissensus as fundamental to democracy. In this way, an agonistic democracy is different from more formalized practices of deliberative democracy that privilege consensus and rationality. Much of the motivation for theories of agonism is to work against "third-way" and "centrist" politics, which tend to emphasize rationality and consensus as the basis for democratic decision making and action.[4]

Theories of agonism emphasize the affective aspects of political relations and accept that disagreement and confrontation are forever ongoing. For political theorist Chantal Mouffe, this is a consequence of what she calls the "paradox of democracy": we strive for a pluralism that we know can never be achieved. As she states (Mouffe 2000b, 15–16),

What is specific and valuable about modern liberal democracy is that, when properly understood, it creates a space in which this confrontation is kept open, power relations are always being put into question and no victory can be final. However, such an "agonistic" democracy requires accepting that conflict and division are inherent to politics and that there is no place where reconciliation could be definitively achieved as the full actualization of the unity of "the people." To imagine that pluralist democracy could ever be perfectly instantiated is to transform it into a self-refuting ideal, since the condition of possibility of a pluralist democracy is at the same time the condition of impossibility of its perfect implementation.

Agonism is a condition of forever looping contestation. The ongoing disagreement and confrontation are not detrimental to the endeavor of democracy but are productive of the democratic condition. Through contentious affect and expression, democracy is instantiated and expressed. From an agonistic perspective, democracy is a situation in which the facts, beliefs, and practices of a society are forever examined and challenged. For democracy to flourish, spaces of confrontation must exist, and contestation must occur. Perhaps the most basic purpose of adversarial design is to make these spaces of confrontation and provide resources and opportunities for others to participate in contestation.

Agonistics: A Language Game is a computational media project by Warren Sack (2004) that illustrates the qualities of agonism by engaging players in a state of agonistic conflict (figure 1.3). In this project, online discussion forums become the shared space in which agonistic conflict takes place. In *Agonistics*, players post messages to online forums with the goal of entering into dialog with other players. In the game or contest, winning occurs by having your own ideas promoted and taken up by others in the discussion forum. In addition to the textual qualities of the project, there is a visual component in which participants are represented as icons on screen, arrayed in a circle. Custom software designed and written by Sack tracks the relative standing of a player's posts in the overall catalog of posts. As a player's ideas and perspectives gain ground in the discussion forum (that is, as others reference them), the player's icon moves away from the periphery and toward the center of the circle. One way to have your idea referenced by others is to take a controversial position, thereby provoking response. In this way, the game and the software that makes it possible

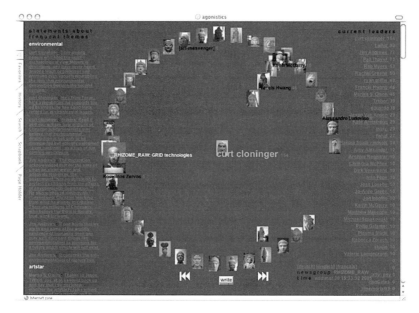

Figure 1.3
Warren Sack, *Agonistics: A Language Game* exhibit, 2002, http://artport.whitney.org/ gatepages/artists/sack

reward the production and maintenance of contestation. A player of *Agonistics* cannot destroy other players, and a player does not want to antagonize the field of discourse so that the exchange ceases, for that would result in a player's standing being diminished. Rather, the game is designed such that a player needs to keep the conflict alive to win. This requires constant and ongoing articulation and expression to produce positions that will sustain the conflictual exchange.

Agonistics: A Language Game demonstrates a key notion of agonism (particularly as developed by Mouffe)—the difference between enemies and adversaries. Mouffe's theory of agonism draws heavily from political theorist Carl Schmitt's formulation of the political as a state of conflict that is based in a distinction between friends and enemies (Schmitt 1996). But rather than framing the conflict as among enemies that seek to destroy one another, the term *adversary* is used to characterize a relationship that includes disagreement and strife but that lacks a violent desire to abolish the other. In this way, agonism reveals its roots in the Greek *agon*: "a public celebration of games; a contest for the prize at those games; or, a verbal contest between two characters in a Greek play" (*OED* 2008). Shared among

the historical and contemporary meanings of agonism is a notion of a particular kind of conflict that is not merely symbolic. It has social, material, and experiential consequences but does not result in the annihilation of the other.

Whereas Mouffe uses the term *adversary* to describe the character of relations between actors and positions within an agonistic democracy, I use that term to describe the character of designed artifacts or systems. In labeling an object as adversarial, I mean to call attention to the contestational relations and experiences aroused through the designed thing and the way it expresses dissensus. Labeling an object as adversarial also shifts the grounds for critique. It requires that the description and analysis of the object bring to the fore the way that its designed qualities enable or model the productive and ongoing questioning, challenging, and reframing that typifies agonism.

Design for Politics and Political Design

Agonistics: A Language Game provides one example of adversarial design as a literal illustration of agonism through game mechanics and the design of game play. Other forms of adversarial design are possible, many of which are less literal and will be taken up in the following chapters. All instances of adversarial design, however, hinge on an understanding of the distinction between *politics* and *the political* and, subsequently, the distinction between design for politics and political design.

The word *political* is often used in a derogatory sense, in phrases such as "It was a purely political decision." On the one hand, such phrases are useful for understanding agonism because they express the conflictual nature of democracy. Yet the derogatory nature of such phrases also signals a belief that conflict thwarts the endeavor of democracy. When people use such phrases, they seem to mean that they want their representatives and leaders to back away from ideological stances and get on to the so-called work of running the city or state or country. But from an agonistic perspective, politics and the political are separate notions that should not be conflated. The distinction emphasizes the difference between ongoing acts of contestation and the administrative operations of government. As Mouffe (2000b, 101) states:

By "the political" I refer to the dimension of antagonism that is inherent in human relations, antagonism that can take many forms and emerge in different types of social relations. "Politics," on the other side, indicates the ensemble of practices, discourses and institutions which seek to establish a certain order and organize

human coexistence in conditions that are always potentially conflictual because they are affected by the dimension of "the political."

This distinction between politics and the political shapes the purposes of adversarial design, and highlights the difference between design for politics and political design. Politics are the *means* by which an organization, municipality, or state is put and held together. Politics are a series of structures and mechanisms that enable governing. These range from laws and regulations to unspoken but observed habits of interpersonal interaction and performances of beliefs and values. Different from these means, the political is a *condition* of life—a condition of ongoing contest between forces or ideals. This condition is expressed and experienced in the dealings between people and organizations in a multiplicity of ways, including debate, dissensus, and protest. This condition can also be expressed and experienced through design.

Most contemporary design projects that purport to support democracy do so in the realm of politics and not the political, and so we can differentiate between design for politics and political design. Design for politics most often works to improve access to information (such as public health information or information regarding organizations and candidates) or to improve the access to various forms of ordered expression and action (such as petitions, balloting, and voting). As used in projects that *apply design to politics*, it emphasizes techniques of merging form and content in aesthetically compelling and functionally appropriate ways to support the means of governance—the mechanisms by which a state, organization, or group is held together. Such work is imperative but is not inherently political in an agonistic sense. Perhaps the best way to understand the difference between design for politics and political design is through a comparison of two contemporary projects.

The Design for Democracy (DfD) initiative within the American Institute of Graphic Arts (AIGA) is emblematic of design for politics. According its Web site, DfD "applies design tools and thinking to increase civic participation by making interactions between the U.S. government and its citizens more understandable, efficient and trustworthy" (AIGA 2008).[5] The programs within the DfD initiative are broad reaching. The *Get Out the Vote* program solicits nonpartisan graphic design to promote voter registration and participation; the *Government Officials: Get Help* program provides design services to "make government more accessible, transparent, and efficient" (AIGA 2008); the *Polling Place Project* solicits and presents citizen journalism documenting the voting experience in the United States;

a design advocacy program promotes the importance of design in government; and the *Ballot and Election Design* program strives to improve the experience and increase the efficacy of voting through the redesign of ballots, polling place signage, instructional materials, and poll-worker training materials (Lausen 2007). The efforts of DfD have had direct, measurable, and laudable effects. In 2007, the U.S. Election Assistance Commission accepted the AIGA guidelines for ballot and polling place information design; the *Polling Place Project* has garnered significant participation with thousands of photos submitted and presented; and the *Get Out the Vote* project has produced dozens of compelling posters, replicated in the thousands. This work is exemplary of design for politics in that its purpose is to support and improve the mechanisms and procedures of governance. This is clear in the positioning of the work and the stated motivations, such as increasing voter participation, making government more transparent and efficient, and increasing the efficacy of voting through design.

As a counterpoint, the *Million Dollar Blocks* project provides an example of political design. This project is implicitly contestational and strives to investigate an issue and raise questions concerning that issue. In doing so, it demonstrates one notion of what design for democracy might be like from the perspective of agonism.[6] Developed by Laura Kurgan at the Spatial Information Design Lab at Columbia University (Kurgan 2005), *Million Dollar Blocks* uses geographic information systems to map crime-related data. Rather than taking the common approach to crime mapping and asking, "Where does crime occur?" or "Who are the victims of crime?," Kurgan began her project with the question, "Where does the prison population come from?" The primary product of the project is a series of maps of four cities (Phoenix, Wichita, New Orleans, and New York) that graphically depict the distribution of the home residences of prison inmates (figures 1.4 and 1.5). In addition to the maps and related information graphics, Kurgan and her colleagues have produced an exhibition; two self-published books documenting the process and issues, *The Pattern* and *Architecture and Justice*; and a scenario-planning workshop with design professionals and community, civic, and social justice organizations and individuals.[7]

The *Million Dollar Blocks* project is political design because it reveals, questions, and challenges conditions and structures in the urban environment; it opens a space for contestation; and it suggests new practices of design in mapping and urban planning. Unlike DfD, *Million Dollar Blocks* does not work directly to support or improve existing means of

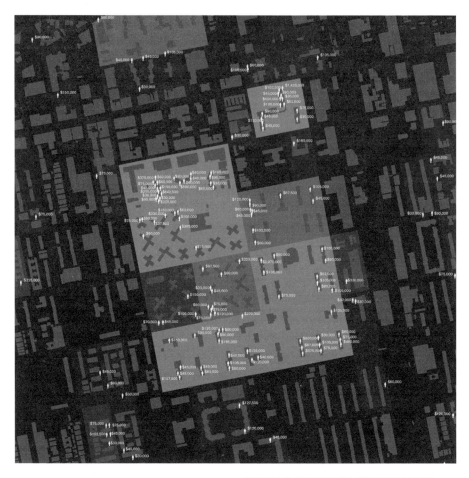

BROWNSVILLE, BROOKLYN

IT COST 17 MILLION DOLLARS TO IMPRISON 109 PEOPLE FROM THESE 17 BLOCKS IN 2003. WE CALL THESE MILLION DOLLAR BLOCKS. ON A FINANCIAL SCALE PRISONS ARE BECOMING THE PREDOMINANT GOVERNING INSTITUTION IN THE NEIGHBORHOOD.

Figure 1.4

Map of the Brownsville neighborhood in Brooklyn, New York, showing prison expenditures (in U.S. dollars) by census block, 2003. From the *Million Dollar Blocks* project. Images provided courtesy Spatial Information Design Lab, Graduate School of Architecture, Planning and Preservation, Columbia University, 2006. Architecture and Justice project team: project director Laura Kurgan, Eric Cadora, Sarah Williams, and David Reinfurt.

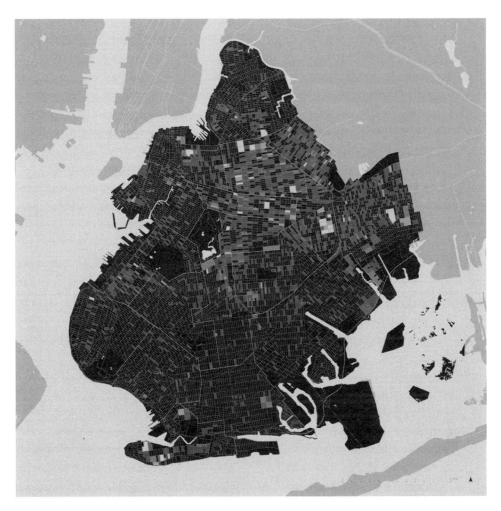

Figure 1.5
Map showing high-incarceration-rate blocks in Brooklyn, New York, 2003. From the
Million Dollar Blocks project. Images provided courtesy Spatial Information Design
Lab, Graduate School of Architecture, Planning, and Preservation, Columbia Uni-
versity, 2006. Architecture and Justice project team: project director Laura Kurgan,
Eric Cadora, Sarah Williams, and David Reinfurt.

governance. Rather, by asking, "Where does the prison population come from?" and producing a series of designed objects to explore that question and its implications, Kurgan reframes the discussion of crime and the built environment. As she states (Kurgan 2008):

By focusing solely on [crime] events, the human underpinnings of crime were left largely unaffected. When we shift the maps' focus from crime events to incarceration events, strikingly different patterns become visible. The geography of prison differs in important ways from the geography of crime.

A key question for Kurgan is, "Is there a pattern in the data that reflects a pattern in an underlying condition?," and if there is, "How might the recognition and interrogation of that pattern bring to light inequalities as they are manifested in the urban environment?" The title of the project—*Million Dollar Blocks*—comes from the amount that the government is spending annually (more than $1 million) to incarcerate residents of certain street blocks. The discovery and articulation of this pattern raises further questions such as "Who lives on those blocks?," "What are those blocks like?," and "How might that money be otherwise spent and perhaps to better effect?"

Making this distinction between design for politics and political design is important because it helps to make sense of how projects such as *Million Dollar Blocks* and Jeremijenko's *Feral Robotic Dogs* project fit into a broader endeavor of using the practices and products of design to shape and contribute to public discourse and civic life. We are familiar with design for politics but less familiar with political design. We have fewer ways of describing and analyzing what the political is doing and how it is doing it. One value of adversarial design is that it provides a way of framing and discussing a broad range of projects and their effects. Adversarial design is both a way of doing the work of agonism through designed things and a way of interpreting designed things in terms of their agonistic qualities.

Doing the Work of Agonism

The foundation of agonism is a commitment to contestation and dissensus as integral, productive, and meaningful aspects of democratic society. To claim that adversarial design does the work of agonism means that designed objects can function to prompt recognition of political issues and relations, express dissensus, and enable contestational claims and arguments. In the case of *Million Dollar Blocks*, the maps document patterns of incarceration

and urban development and serve as objects that raise questions and proffer implicit judgments about the allocation of capital and social resources within cities. By revealing the conditions of political issues and relations, adversarial design can identify new terms and themes for contestation and new trajectories for action.

For example, beyond the literal naming of a condition (as million-dollar blocks), the *Million Dollar Blocks* project reveals previously obscured configurations in the cycle of crime and incarceration, making them available for debate, further investigation, and as leverage positions in future actions. In subtle ways, the designed artifacts and activities of the project challenge the common understanding and use of crime statistics and practices of mapping, and they raise questions concerning the facts, understandings, and implications that are often left out of analyses and representations. This, in turn, provides an opportunity for productive dissensus concerning the relationships between crime, the built environment, and policy and the political effects of maps as artifacts and mapping as a process. Kurgan (2008) herself seems well aware of this, when she states,

With this map, we stop talking about where to deploy police resources or how to track individual prisoners for institutional purposes; instead we begin to assess the impact of justice on a city, even a city block, and start to evaluate some of the implicit decisions and choices we have been making about our civic institutions.

The purpose of design in *Million Dollar Blocks* (and of adversarial design more generally) is not to achieve a readily identifiable form or instance of change but instead to prompt debate and serve as a kind of material evidence in political discourse. Whereas design for politics strives to provide solutions to given problems within given contexts, political design strives to discover and express the elements that are constitutive of social conditions. For example, whereas the DfD *Ballot and Election Design* program works to resolve problems in the process of voting, the *Million Dollar Blocks* reveals and documents correlations between imprisonment and qualities of the urban environment.

Although not an exhaustive review of contemporary design projects, this comparison of the AIGA DfD initiative and *Million Dollar Blocks* outlines distinctions between design for politics and political design and makes a case for them as different endeavors. In doing so, it also provides insights into what it means to do the work of agonism. With this bit of background into agonism, it is worth returning to design to contextualize adversarial design within fields of contemporary practices.

The Pluralism of Design

One challenge with discussing design is that design is simultaneously familiar and elusive. It refers to activities that involve all people and also to formalized activities that are done by people who identify professionally as designers. Since the early 2000s, there has been a reinvigoration of the design fields and of the general public's awareness of and interest in design, as evidenced by an increase of popular design journalism. One outcome of this increased interest is that the distinctions between professional and nonprofessional design are becoming increasingly vague. In the past, a distinction could be made between professional and nonprofessional design based on tools, an artifact's technical complexity, or aesthetic consideration of an artifact. But such distinctions are eroding. Everyone can use desktop publishing and media software to create and orchestrate images, text, sounds, and motion. Books such as Ellen Lupton's *DIY: Design It Yourself* (2006) introduce professionals and nonprofessionals to the basics of form and composition to heighten the aesthetic considerations of a range of artifacts. Even the technical complexity of electronics and batch-manufacturing projects are tamed and popularized in a new breed of magazines such as *Make* and *ReadyMade* and Web sites such as *Instructables* that provide resources for independent designers who often have not been professionally trained.

At the same time that nonprofessional design is proliferating, the professional boundaries of design continue to expand. Educational programs are growing, and dozens of professional design organizations and scholarly journals are published regularly. Design-related activities and subjects include familiar forms such as fashion, industrial, interaction, and graphic design as well as less familiar forms such as service and organizational design. As new fields of design emerge regularly and the range of practices within the fields of design constantly change, more and more people identify themselves or are identified by others as designers.

So what are we talking about when we talk about design?

The renowned social scientist Herbert Simon was one of the early thinkers to place design in a broad context relevant to contemporary practice. For Simon, there were two key aspects of design. First, it was a hallmark of any professional activity: medicine, policy, management, engineering, and architecture all engage in design. Second, it was concerned with the artificial (how things might be) and not with the natural (how things are), which concerned prior sciences. In *The Sciences of the Artificial*, Simon (1996, 111) offers this now classic definition of the activity of design:

"Everyone designs who devises courses of action aimed at changing existing situations into preferred ones." As the practice of design and design studies has matured, so too has our thinking about what design is. More recently, design studies scholar Richard Buchanan (2001, 191) has offered the following definition of design: "Design is the human power of conceiving, planning, and making products that serve human beings in the accomplishment of any individual or collective purpose." Like Simon's definition, Buchanan's definition of design allows for the discovery and assertion of a wide range of activities under the rubric of design. And both definitions emphasize design as action-oriented.

Buchanan and Simon represent two opposing positions in contemporary design: those who assert that design is or should be a science, and those who do not. It was important for Simon to consider design as a science and the study of design as a scientific endeavor. The emphasis in such an approach is on the decision-making processes of the designer, the empirical study of the effects of design activity and outcomes, and the identification of the factors that produce such effects. The purported benefit of such a scientific approach is that it allows practitioners of design to be more precise and effective in design activity and research and to make claims that are based in fact, not assumption. In contrast to Simon's scientific approach, Buchanan (2001) considers design to be a liberal art and roots understanding and discourse about design in the humanities, not the sciences. Buchanan's primary interest is in casting design as a contemporary form of rhetoric, its concern being the communication of belief and the incitement to action through argument. According to Buchanan, this notion of design as rhetoric assumes that designers are "agents of rhetorical thinking in the new productive sciences of our time" and that the discipline of design "employs rhetorical doctrines and devices in its work of shaping products and environments" (Buchanan 2001, 187). The implication of casting design as rhetoric is that "In approaching design from a rhetorical perspective, our hypothesis should be that all products—digital and analog, tangible and intangible—are vivid arguments about how we should lead our lives" (Buchanan 2001, 194). Given such a position, design practice and scholarship should focus on the means of constructing and analyzing the arguments enacted or embodied in design process and products.

In this book, design is discussed as a liberal art with an emphasis on the rhetorical aspects of design. But even across those contrasting positions, there are shared qualities of design. Regardless of whether one considers design as a science or a liberal art, three general characteristics of design

bind together multiple design positions and practices. Its first characteristic is that *the practice of design extends the professions of design.* Anytime a deliberate and directed approach is taken to the invention and making of products or services to shape the environment through the manipulation of materials and experiences, this is design.

Its second characteristic is that *the practice of design is normative.* It is how things could or ought to be. As a normative endeavor, design stands in contrast to disciplines or practices that produce descriptions or explanations alone. Design attempts to produce new conditions or the tools by which to understand and act on current conditions. In the process of doing so, designers and the artifacts and systems they produce assert claims and judgments about society and strive to shape beliefs and courses of action. Claiming and asserting that things should be other than they are and attempting to produce the means to achieve that change are not neutral activities. Positioning design as a normative endeavor has consequences: it opens the practice and products of design to ethical, moral, and political critiques.

Its third characteristic is that *the practice of design makes ideas, beliefs, and capacities for action experientially accessible and known.* For example, even when information is expressed to an audience by text alone, the text is taken as visual material to be manipulated and sculpted to provoke specific patterns of reading, association, and meaning making through the practices of graphic and information design. Such treatment of textual data can be traced through early twentieth-century examples of book, poster, and newspaper design through to contemporary forms of computational media. The visualization work of designer Ben Fry provides salient examples. Fry uses information design to sculpt data with the basic of elements of type, line, shape, and color. The goal is to increase understanding of scientific information and make new connections and perhaps even new scientific discoveries. His creative expression of data extends the standard forms of documentation and communication used by scientists in truly novel ways. For example, when Fry (2001a) presents the 13 million letters from the genetic code of human chromosome 21 rendered in a 3-pixel font into an 8-foot by 8-foot image, the resulting image can be considered an attempt to make the data of that chromosome experientially accessible and known so that we might viscerally understand it as information and come to a greater appreciation of the complexity and vastness of human genes. More directly associated to action is Fry's *Isometric Haplotype Blocks* (2001b) interface, which presents a set of genetic data in six views, allowing the user to navigate among the views and produce a new perspective of comparison

and contrast, ideally for the purpose of advancing scientific discovery.[8] Such an emphasis on the production of experiential forms extends nearly all design fields, from industrial to organizational design. With each field, the materials that are rendered for experiential effect change to reflect the traditions of that field and the skills of the designers, but the emphasis on making ideas, beliefs, and capacities for action experientially accessible and known remains consistent across all varieties of design.

In terms of the range of activities (from fashion to medicine) and of perspectives (from scientific to humanistic), design covers a broad swath of contemporary cultural production. What we are talking about when we talk about design is both a field and practice. It includes the professional fields of design such as graphic, information, industrial, and interaction design and the products produced within these fields. It also includes the work of nonprofessionals who draw from or reference design fields and products in their work—the work of those who engage in the practices of design but might not identify themselves as designers. This practice of design is an implicitly normative endeavor of conceiving and producing experiential forms—artifacts, systems, events—to shape beliefs and courses of action. What distinguishes adversarial design is that it works to shape beliefs and courses of action in regard to political issues.

Critical Design and Tactical Media

Adversarial design does not exist in a vacuum of cultural production, and instances of it span different fields, subjects, styles, and movements. In fact, one motivation for this inquiry is to provide a broad and coherent framework for describing and analyzing a range of contemporary designed things that seem to do the work of agonism. Critical design and tactical media are two modes of cultural production that exemplify many qualities of adversarial design and warrant attention. They also raise important issues concerning the confluence of art and design and provide an opportunity to clarify the role of adversarial design as a theoretical construct—a tool to think and make with—rather than as a means of naming a movement.

Anthony Dunne and Fiona Raby coined the term *critical design* in the mid-1990s to describe a practice of design that uses products to ask questions and raise issues in society and culture. Critical design is now an established body of work that originates and operates from within the professional fields of design and expresses a critical, if not always political, stance through designed things. As Dunne and Raby (2001, 58) describe it:

Critical design is related to haute couture, concept cars, design propaganda, and visions of the future, but its purpose is not to present the dreams of industry, attract new business, anticipate new trends, or test the market. Its purpose is to stimulate discussion and debate amongst designers, industry, and the public about the aesthetic quality of our electronically mediated existence. It differs too from experimental design, which seeks to extend the medium, extending it in the name of progress and aesthetic novelty. Critical design takes as its medium social, psychological, cultural, technical, and economic values, in an effort to push the limits of the lived experience, not the medium.

Early instances of Dunne and Raby's critical design work focused on information technology. Products within the *Hertzian Tales 1994–1997* series (Dunne and Raby 1997) explored the implications of increased radio and magnetic waves in the environment as a consequence of the increasing numbers of digital and electronic devices. The prototype products in these series took a decidedly dark tone, embodying what Dunne and Raby referred to as "design noir" to explore issues of product development and use often unaccounted for in the mainstream design festivals and product press releases (Dunne and Raby 2001). For example, the *Faraday Chair*, which appears like a human-size amber aquarium, is designed to provide a respite from the otherwise ubiquitous presence of radio waves and their unknown effects on the body, offering "a retreat, a new place to dream, away from the constant bombardment of telecommunication and electronic radiation" (Dunne and Raby 1997). More recent work by Dunne and Raby has focused on the future uses and implications of biotechnology and robotics and continues to use the design of prototype products to prompt questions about the kinds of experiences and lives we are or may soon be encountering through technology. The project *Is This Your Future?* (2004) explores the possibilities of home bioenergy production, including the harvesting of energy from dead animals and the recycling of human waste, and *Technological Dreams Series: No.1, Robots* (2007) explores alternate forms of human-robot interaction, such as neurotic or needy robots.[9]

Tactical media is a term used to describe diverse works and practices that manipulate technology to produce artifacts, systems, and events that critique contemporary society. Tactical media is an example of a practice within the arts that engages in the practice of design and the production of designed things. As described by media theorists David Garcia and Geert Lovink (1997), "It is about a form of art that meets activism with a positive attitude towards contemporary digital technology." In contrast to critical design, in which a political stance is not explicit and the political aspects of the work are often unaccounted for, tactical media put forth an overt

and unambiguous political, often agonistic, perspective. This is political action of a certain kind, as Rita Raley describes in her book *Tactical Media* (2009, 1): "These projects are not oriented towards the grand, sweeping, revolutionary event; rather, they engage in a micropolitics of disruption, intervention, and education." These micropolitical works cross media and technology boundaries, taking a variety of forms from performance to software to workshops. For instance, the collective Critical Art Ensemble (CAE) has produced several installations and performance events about issues surrounding biotechnology. In collaboration with artists Beatriz da Costa and Claire Pentecost, CAE produced the installation *Molecular Invasion* (2002–2004) on the subject of genetically modified organisms—corn, soy, and canola plants engineered by the Monsanto Corporation. The installation consisted of various stands of the plants on display in a grow-room environment, interpretive materials (wall texts and an interactive computer kiosk), and participatory science-theater events in which the artists worked together with students in the gallery space to attempt to reverse engineer the Monsanto plants.[10] As another example, the Institute for Applied Autonomy (IAA), a collective, created the software application *iSee* (2001), which maps all of the known surveillance cameras in New York City. It allows users to mark starting and ending points and then generates a "path of least surveillance" through the city.[11] Leveraging the capabilities of interactive maps, *iSee* provides a clear and familiar function (route planning), raises awareness of the ubiquity of surveillance, and also provocatively provides a means for attempting to circumvent this surveillance.

Critical design and tactical media provide incentives for developing ways of articulating agonism through design to better understand, describe, and analyze the political qualities of such work. Critical design and tactical media also surface art as a potential issue. For some, critical design veers close to art, and it certainly draws from art practices and history. And as tactical media is art, can it be spoken about from the perspective of adversarial design?

There is a long-standing tension between art and design. Since the inception of modern design, the two fields have regularly drawn from each other, while also endeavoring to maintain distinctions. The term *designart* has been put forward to describe works that operate in the interstices of the fields, which, as art critic Alex Coles (2007, 10) notes, "form[s] more of a shifting tendency than a fixed movement or category." Rather than trying to carve distinctions between the fields of art and design, however, it is more productive to allow their practices to overlap and intermingle, as seems to be their character in contemporary culture (Coles 2007). Within

this book, works of art—works described by either their makers as art or placed within the cultural category of art by critics and theorists—are woven into the exploration of adversarial design, just as these works themselves incorporate design practices. Likewise, works from within the field of design that draw from art will not be shown any prejudice. Directly stated, the issue is not whether a work is categorized as art or design proper but rather how works employ design in an adversarial manner.

Adversarial design is a theoretically informed construct for understanding, describing, and analyzing a range of objects and practices. Critical design and tactical media are two contemporary practices that produce some work that could be characterized as doing the work of agonism. But not all work falls within these categories. For instance, *Million Dollar Blocks* would not be readily characterized as critical design or tactical media. Thus, adversarial design does not just name (or rename) a movement or genre. It provides a means of characterizing and discussing practices and objects that brings to the fore the agonistic qualities of the work across a multitude of movements and genres. Asserting the claim that some designed things do the work of agonism, the charge of this inquiry is to elucidate how they do so. But getting at more precise descriptions of how adversarial design does the work of agonism requires more specificity in analysis. One way to achieve that specificity is by focusing on a particular medium, and computation is a timely and robust medium to explore.

Computation and Adversarial Design

Examples of adversarial design can be found across mediums and forms. Silkscreen posters, celluloid films, and steel sculptures are just as capable of doing the work of agonism as are computer animations, digital photography, and virtual worlds. A history of twentieth-century agonistic work would include examples from all forms and mediums of aesthetic expression in design and the arts—from the collage work of the Dadaists and Futurists, to the sculptural manipulations of the everyday by the Surrealists, to the posters of the Grapus collective in the 1960s, 1970s, and 1980s, to the contemporary architectural, artifact, and performance-based works of Krysztof Wodiczko.[12] Just as agonism argues for a pluralism of political positions, so too does adversarial design manifest in a pluralism of mediums and forms.

Although the defining quality of adversarial design is the way it functions and not its form or medium, the mediums and forms of design are central to the activities of design and the experience of designed objects.

Attending to these mediums and forms of design is imperative for insightful descriptions and analyses of artifacts and systems. In some ways, this is a commonsense notion, particularly regarding discussions of art and design. Few scholars would expect a painting and a sculpture to be perceived in the same way and have the same effect on viewers, even if they share subject matter. Likewise, although a common hammer and an air hammer share a general functionality of driving nails, the process of designing each product, the experience of use, and the capabilities they provide vary in nontrivial ways. In a similar manner, although the work of agonism can be done in any medium, the kinds and qualities of work done shifts from medium to medium.

My focus is on designed artifacts and systems that make use of the qualities of computation as a medium. The purpose of focusing on a single medium is to develop a kind of medium particularity in description and analysis. This attention to medium grows from a diverse but coalescing body of scholarship, and the choice of computation as the focus is grounded in the contemporary practices and objects of design. Both of these subjects—the focus on computation and medium particularity—deserve a brief discussion before proceeding, as they frame this inquiry into adversarial design.

Why a Focus on Computation?

Three factors in contemporary design motivate a focus on the medium of computation. First, although design extends the realm of technology, there is a defining affinity between design and technology; second, computation is a lively contemporary technological domain that spans practices and forms; and third, the artifacts and systems produced via computation have particular characteristics and deserve close readings. Each of these is addressed briefly here, leaving for the following chapters the full discussion of these factors and the ways that they combine together and intersect with the political.

In large part, the focus on computation is a continuation of a historical trajectory within design to explore technological possibilities in the making of products and services and the experiences they provide. Although technology is not the only site of design, throughout the history of design there has been a defining affinity between design and technology. The practices of design and varieties of designed form often develop in concert with the prevailing technologies of an era. This relationship between design and technology is reciprocal: design is a way of experimenting with

and domesticating technology, and the capabilities and limitations of technology often set the scope and challenges of design activity. This defining affinity between design and technology can be traced back to the origins of what we know today as contemporary design in the beginnings of the twentieth century. For the Constructivists and those at the Bauhaus, the mechanical automated machine that enabled mass production was the defining technology of the time and set the character of then contemporary design.[13] To do design was to work with and reflect an informed consideration of the mechanical automated machine. Attention was paid to the machine as a device for the generation of forms and to the machine as an organizing principle for then modern culture.

The pattern of treating technology as simultaneously an instrument and subject of design continues today. At the turn of the twentieth century, the mechanical machine or mechanization constituted the dominant technology of concern for design, but today the computer or more accurately the medium of computation is the dominant technology. At this historical moment, the medium of computation is salient to design studies because it shapes design practice and constitutes a distinctive site of design invention. The medium of computation encompasses a multiplicity of components, including algorithms, languages, protocols, hardware, software, platforms, and products. To understand computation as a medium requires exploring the ways those components can be used to endow artifacts and systems with distinctive qualities. One fundamental task for contemporary design studies is to understand what it means to do design with computation as a medium that, like any medium, has particular characteristics. The Bauhaus designers strove to understand the automated machine as providing distinctive expressive capacities and limitations, and today designers, artists, and scholars attempt to understand computation as a medium.

As informatics scholar Paul Dourish (2001, 163) notes, when engaging computation as a medium rather than just a tool, "Meaning is conveyed not simply though digital encodings, but through the way that computation enlivens those encodings with semantic and effective power." Examining computation as a medium thus requires an understanding and elucidation of how this "enlivening" occurs—that is, how designers employ and exploit the capacities and limitations of the components of computation (such as algorithms, languages, protocols, hardware, and software) to make certain distinctive expressions and experiences come about. For adversarial design, the task is to identify and describe how the qualities of computation are used for political ends and what political issues they bring forth. The questions to be asked are "What modes of political exchange,

expression, and argument are particularly enabled or enacted by the medium of computation?" and "What does it mean to do political design with computational technology?"

Medium Particularity

Although the focus on computation is motivated in part by computation's place in contemporary design, it is also motivated by a desire to develop a medium particularity in scholarly accounts of design. Since the late twentieth century, there has been a turn toward objects across many scholarly fields, and along with this, an interest in practices and products of design. Politics and political issues are often present, sometimes at the forefront of this turn. This suggests an opportunity for more exacting analyses of designed objects to reflect how a given medium figures into the political qualities and affects that designed objects express or are endowed with.

The works of Langdon Winner and Bruno Latour in science and technology studies and of Jane Bennett in political theory outline a series of issues and opportunities for an interdisciplinary approach to investigating the political qualities of objects and design. In his influential essay "Do Artifacts Have Politics?," the philosopher of technology Langdon Winner (1980) sparked a course of inquiry concerning the relations between design, power, and the built environment. In this essay, Winner suggests that highway overpass bridges designed by New York urban planner Robert Moses enforced a racist doctrine. According to Winner, the bridges were designed with a height that would not permit buses to pass underneath, thereby barring people of color (who depended on public transportation) from accessing beaches near the city. Since the essay's first publication, scholars have debated Winner's claims and position on multiple grounds, questioning the empirical validity of Winner's claim by noting that the bridges did not block all of the public transportation routes to the city beaches. And they have resisted Winner's theoretical position as one of technological determinism (Joerges 1999). These fundamental debates about the relationship between design, power, and the built environment continue today, extending beyond the question of bridges to all manner of designed artifacts and systems. The essence of these debates tends to be about where power is located—in the intention of the designer, in the object itself, or across a network of material and social relations.

More recently, science studies scholar Bruno Latour (2005) has proffered the notion of an "object-oriented democracy" as a way to describe and

analyze the contemporary political condition. In such a democracy, objects become a means and medium through which politics and the political are enacted. As Latour (2005, 15) states, "Each object gathers around itself a different assembly of relevant parties. Each object triggers new occasions to passionately differ and dispute." For Latour, objects are one way to engage in and experience politics and the political. This may sound similar to Winner's position, but Latour extends Winner's assertion in a simple but important way: artifacts may have politics, but these politics change. The politics of artifacts are determined relationally by their engagement with other objects and discourses, all of which are subject to variation over time and across contexts. Thus, unlike Winner's position, which requires recourse to the intention of the designer, Latour's position expresses a more distributed notion of agency and effects as the forces and capacities of objects are dynamic and contingent. Objects and design still have political significance and effect, but that significance and effect are always shifting.

In her book *Vibrant Matter: A Political Ecology of Things*, political theorist Jane Bennett (2010) draws together Latour and Gilles Deleuze to investigate the agency of assemblages, both human and nonhuman. Like Winner and Latour, Bennett draws objects in a discussion of politics, noting that objects have been too long absent from political theory. She examines the capacities and effects of a range of assemblages, from the power grid to potato chips, discussing the ways that such assemblages figure in the exertion and experience of power, influence, and consequence. For Bennett, such a move toward objects and materiality is necessary to change how we critically make sense of and respond to the contemporary political condition. As she states, "a politics devoted too exclusively to condemnation and not enough to a cultivated discernment of the web of agentic capacities can do little good" (Bennett 2010, 8). In a sense, this inquiry into adversarial design complements Bennett's: this inquiry is motivated by a desire to bring political theory into the discourses of design more fully and to develop a design criticism characterized by a "cultivated discernment" of the political qualities of artifacts and systems.

The work of scholars such as Winner, Latour, and Bennett provides a theoretical backdrop for a turn toward objects and their political qualities and potentials. But these authors do not directly engage the medium of computation. To investigate how design does the work of agonism through the medium of computation requires drawing from the field of digital media studies. This scholarship examines software and hardware and provides inroads to investigating what it means to do design with the medium

of computation. For example, canonical texts such as Janet Murray's *Hamlet on the Holodeck* (1997) and Lev Manovich's *The Language of New Media* (2001) identify distinctive qualities of computation and computational objects that define the medium. These texts lay the foundation for the development of software studies, which take computer code and applications themselves as subject of inquiry. Moving beyond software, in *Racing the Beam: The Atari Video Computer System* (2009), Nick Montfort and Ian Bogost advance a notion of platform studies as a way of getting even closer to understanding computational machines and how the qualities and affordances of circuits and hardware affect the design of computational cultural artifacts. For example, they explore the ways that the hardware of the Atari 2600 gaming platform managed sprites in memory and how that particular configuration of capacities and limitations affected game design and players' subsequent experiences and expectations of video-game play.

These diverse yet complementary discourses signal a renewed attention to the significance of objects and mediums and their relations to understanding politics and the political. But more work needs to be done in synthesizing and extending these discourses. To call for an object-oriented democracy is the right first step, but it simply sets the trajectory for a course of inquiry. There is a need to attend more closely to the designed qualities of artifacts and systems and the varieties of political expression and enactment. Adversarial design, both as a way of doing the work of agonism through artifacts and systems and also as a way of interpreting artifacts and systems in terms of their agonistic qualities, is an attempt to do just that.

The Structure of the Inquiry

In this book I analyze a series of designed computational artifacts and systems in order to better understand their political qualities and how the medium of computation is used in novel ways to express political issues. To do this, I have organized these artifacts and systems into three categories—information design, social robots, and ubiquitous computing. Although within each of these categories there is a diversity of forms and functions, each category also highlights a fundamental quality of the medium of computation and brings to the fore distinctive attributes for political design. For example, information design highlights procedurality, which is the way that software generates representations and enables new forms of political images and interactive visual expressions. Social robots highlight embodiment, or the dynamic coupling of objects with

the environment, and in the process raise issues concerning our future relations with intelligent artifacts. And ubiquitous computing highlights connectedness and the ways in which everyday objects become networked computational things, enabling new possibilities for participation in political expression. The purpose of making such categorical distinctions is to move closer to a medium particularity in design scholarship. In addition, the computational qualities of each category lend themselves to different tactics of adversarial design—revealing hegemony, reconfiguring the remainder, and articulating collectives. By exploring these categories and tactics together, my aim is to detail the ways that computational artifacts and systems can be understood as doing the work of agonism through design.

2 Revealing Hegemony: Agonistic Information Design

Money and politics have always gone together, and wealth has wielded influence since the beginnings of democracy. So it is not surprising that elected representatives are influenced by the individuals, corporations, and interest groups that fund their campaigns. With improved access to data and new ways of expressing information, novel computational forms illuminate in greater detail and with new cleverness this age-old entanglement of money and politics. For instance, the computational visualization *State-Machine: Agency* (Carlson and Cerveny 2005)[1] depicts the relationship between United States senators and their campaign contributors (figure 2.1). In the digital project, senators are represented as either red or blue circles, depending on their political party affiliation, and the size of their circle is determined by the total amount of campaign funds received. The circles are placed on the screen relative to the amount of funding received from one of three variable funding sources. Each funding source is represented by a plus sign, whose size is determined by the total number of dollars contributed to all campaigns. Funding sources such as lawyers and law firms, which contributed $744,660,550 to all Senate campaigns in 2007, are visually represented as proportionately larger than funding sources such as public-sector unions, whose contributions totaled $7,935,381. A senator who received more funding from lawyers and law firms than from public-sector unions would thus appear closer to that representative plus sign. Using menus in the interface, users can select different combinations of funding sources, resulting in the display of different images. Each new image reveals a different pattern of associations between senators and campaign contributions.

In many ways, *State-Machine: Agency* is familiar as a computational visualization. It draws together and renders a complex set of data; it makes use of standard visual cues such as shape, size, and color to assign

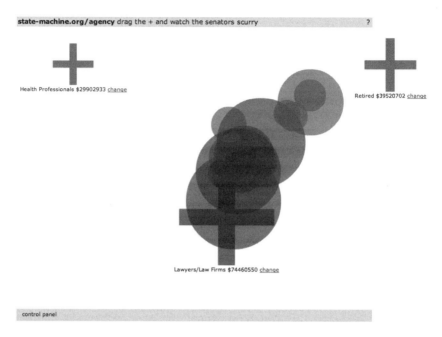

Figure 2.1
Max Carlson and Ben Cerveny, *State-Machine: Agency* (2005), http://state-machine
.org

significance to the data; and through a simple interface, it enables user interaction (by manipulating variables, users can explore the data and generate new representations based on their interests and desires). But beyond these familiar qualities and mechanisms, *State-Machine: Agency* is distinctive in ways that make it exemplary of adversarial design. Foremost, the visualization assumes a decidedly political stance. Because of this explicit political stance, it diverges sharply from the tradition of visualization as a scientific technique that is presumed devoid of bias. This political stance can be immediately perceived in the title. In computer science, a state machine is a model of a set of possible behavioral relations between input, output, and action in which the status of the system is known, stored, and available to be operated on by procedural means. The title thus draws an association between an algorithmic process, which suggests a notion of the determined or expected, and the ways in which a particular political state operates. In case the perspective is not clear from the title of the project, the introductory screen to the visualization states, "Money drives the American political system."

The political stance is not expressed only by discursive means. The political stance is an integral part of the visualization itself, expressed through the interactive qualities of the visualization. Clicking and dragging on a representative circle allows the user to pull a senator away from a funding source momentarily, but as soon as the cursor is released, the circle bounces back into place, its position defined by its relation to the selected funding sources and their comparative contributions. The design of the visualization does more than simply present data. It expressively renders the associations between data, illustrating in an interactive form the notion that politicians are bound to their positions, which are defined by those that give them money.

Visualizations such as *State-Machine: Agency* are a distinct kind of computational object that is emblematic of computational information design. They merit attention because they have become one of the most recognized forms of expressive computational media and constitute an area of considerable design activity. Far extending the purview of their origins in the sciences, computational visualizations have become a familiar cultural form. They commonly appear as a means of explanation in popular visual media, such as print advertising and television news programs. Within some Web sites, computational visualizations have transitioned from being explanatory support material to being the content itself. The *New York Times*, for example, has developed a series of computational visualizations that are self-contained "news stories" of a new kind. The *Naming Names* (Corum and Hossain 2007)[2] visualization is one such example. The visualization allows users to explore who referred to whom in the Democratic and Republican debates in the early part of the 2008 United States presidential election. By interacting with the visualizations, users can discover patterns of referencing among candidates over time. The inclusion of the quotes in which a candidate was named further allows users to develop an understanding of the context of the references. Through this combination of the techniques of information design and the capacities of computation, *Naming Names* intimates a notion of visualization as a kind of journalism.[3]

In addition to their use in news media, computational visualizations are also embedded within other media forms as aesthetic elements or as tools for learning, play, or reflection. Contemporary films, particularly those involving science fiction, regularly use computational visualizations and other forms of information design as visual props to contribute to a contemporary technological aesthetic. As design critic Peter Hall (2008, 122) notes, "Cascading veils of information, as famously depicted in the 1999

film *The Matrix*, have become a defining signifier of our age." Visualization and the aesthetics and practices of computational information design express a cultural moment in which information is abundant, and designers are challenged to make sense of and manipulate that information for social or cultural effect.

Because computational visualization and computational information design are common cultural forms, designers and artists are experimenting to extend the contexts, content, and purposes of information design in new directions. Consider *The Dumpster* (Levin, Nigam, and Feinberg 2006),[4] which depicts breakups mined from an online journal service, allowing users to surf these moments, or consider *We Feel Fine* (Harris and Kamvar 2005),[5] which depicts emotional states gathered from blog postings and allows users to sort and combine feelings and demographics into ever-changing representations of mood. These visualizations are noteworthy for their visual and interactive inventiveness. They elide distinctions between art and design as artists engage the practice of information design and designers veer from rote communication toward authorial expression. They also broaden the scope of information design beyond representing the objective and factual to attempt to represent the subjective and affective. In doing so, such experiments by designers and artists simultaneously utilize and interpret the forms and processes of information design toward new ends.

Some of these experiments by artists and designers are political in an unequivocal sense: they expose and document power structures and networks of influence. This is evident in *State-Machine: Agency,* which depicts a set of financial forces that are exerted by special-interest groups through campaign funding. In such works, artists and designers employ the principal qualities of computation toward decidedly agonistic ends. Those principal qualities and the tactics by which they represent and perform political relations are the subject of this chapter.

Computational Information Design

Information design is the practice of giving form to data so that the data become meaningful. In this context, data are a raw material. The data can be of many types, from digits streaming across the Internet to electrical stimulation in the brain. But such data has no, or minimal, meaning associated with it. In contrast, information is data that have been given structure and shape, translated and contextualized in a way that allows them to be used as the basis for understanding or action. The practices of

information design usually center on activities of rendering data, encompassing the dual meaning of rendering as both an activity of processing and an activity of producing an image or representation.

Like design generally, information design extends beyond any single discipline. It draws from multiple fields, including graphic design, writing and technical communication, information science, cognitive science, and computer science. The products of information design are equally diverse, including typography, layout, text, diagrams, illustrations, documentary photography, maps, and visualizations. Information design as a practice reflects the constitution and role of information generally within society: the practices and forms of information design respond to the changing qualities of data. As the mediums of data transmission and consumption and the materiality of data have changed in the late twentieth and early twenty-first century, so too has the practice of information design changed. Computation has affected the ways in which data are processed and formed into representations and the qualities of those representations. Understanding the practice of computational information design and providing insights into what it means to do design with computation requires identifying and understanding the principal qualities of computation. These qualities shape the practice of information design and provide particular affordances for agonistic expression.

Computational Media and Information Design

In *Visualizing Data*, designer Ben Fry (2008) provides a process for doing computational information design that is structured through seven stages—acquire, parse, filter, mine, represent, refine, and interact. This process is robust enough to guide a practitioner through many computational information design problems. It provides a flexible operational framework for working with data that is informed by Fry's extensive experience in using computation as a medium for information design. But for both the practicing designer and the design scholar, such processes need to be complemented with an understanding of the qualities of computation that underlie such an operational framework and that make computation a distinctive medium for design.

For this discussion of computation and information design, I draw on digital media studies, where much of the richest discussion of computation as a medium has taken place. In part, this may be due to the legacy of media studies and its concern with the characteristics of a given medium, whether radio, film, video, or digital. Extending this concern to

the work of identifying the qualities of computation, there is value in understanding what distinguishes a medium, while avoiding essentializing the medium.

Drawing from digital media studies, the three principal qualities of computation that characterize computational information design are procedurality, transcoding, and the network as a medium of storage, access, and exchange. In computational information design, these qualities combine to render data into information in new ways and to produce new forms of expression. The network as a medium of storage, access, and exchange enables the culling and referencing of an enormous diversity of data; transcoding enables those data to be converted into and across a variety of formats; and procedurality enables the authoring of code to perform these conversions and structure representations algorithmically.

The term *procedurality* refers to the operational characteristic of computation: computation works by executing a set of rules for symbol manipulation. These rules most commonly come in the form of software or, more colloquially, code, which formalizes relationships between symbols and determines how the rules are to be executed, thereby defining the capacities and form of a given computational expression. For many digital media scholars, procedurality is the foundation of computational media. For Janet Murray (1997, 71), procedurality is one of the four essential properties of the digital environment, and she characterizes it as "the defining ability [of the computer] to execute a series of rules." For Ian Bogost (2007), procedurality is central to computation and the basis of a new form of rhetoric performed with computational media, which he calls procedural rhetoric. Both Murray and Bogost identify procedurality as the prime factor in the expressive capabilities of computational media. As Bogost (2007, 5) states, "Computation is representation, and procedurality in the computational sense is a means to produce that expression."

Although Lev Manovich does not use the term *procedurality*, his notion of the "new media object" references procedurality. Manovich (2001, 47) describes the new media object as being "subject to algorithmic manipulation" via programming and then goes on to claim programmability as "the most fundamental quality of new media that has no historical precedent." In effect, Manovich, echoes the centrality of procedurality to computational media. Manovich (2001, 47) further develops the notion of the new media object through a set of general principles: numerical representation, modularity, variability, automation, and transcoding. Of these, transcoding—the capacity of a new media object to be converted from one format to another—is particularly salient to practices and products in

computational information design. As an example, consider any number of interactive map products or location-based services that integrate spatial data, photographs, and user-generated content.[6] These products and services are made possible by the shared structure of the code and the subsequent capacity to weave together digital content, dynamically integrating strings of text with the vector graphics of maps along with animated bitmaps of graphs and images. Such transcoding depends on and expresses Manovich's other four principles. Because of numerical representation and modularity, transcoding can occur, and through transcoding the variability of computational objects is expressed, increasingly in an automated or semiautomated manner.

Finally, the practice of information design today is, in large part, fashioned by the growth of the network as a medium of storage, access, and exchange. The Internet as both a repository of digital data and a medium for the transmission of data has significantly influenced the practice of computational information design by providing access to a massive amount and diversity of data. Photo-sharing services, text chats, and social network sites are all used as sources of data. Reports on stock market activity, environmental conditions, and the weather are also available in real time or near real time. Many databases produced by government agencies and nongovernmental organizations are readily available, covering the broadest of perspectives, from the Central Intelligence Agency's *World Factbook*[7] database of countries and territories to the *Greenpeace Blacklist*[8] database, which registers fishing vessels and companies engaged in illegal, unregulated, and unreported fishing. In addition, commercial databases are readily obtainable for purchase, with cost, not content, being the constraining factor in what kinds of data can be obtained as source material. As Alex Galloway (2007, 566) notes, the use of the Internet as "one giant database, an input stream that may be spidered, scanned, and parsed" constitutes a distinctive methodology that is notable for its awareness of a principal quality of computational media—"the fundamental mutability of data." The creative use of the network as a medium of storage, access, and exchange is thus characteristic of computational information design and suggests yet another facet of what it means to do design with computation.

Taken together, procedurality, transcoding, and the network as a medium of storage, access, and exchange are primary qualities of computational media. To do computational information design requires an understanding of and agility with these qualities. Regardless of whether one uses Ben Fry's seven stages or another model of information design, these qualities of

procedurality, transcoding, and the network as a medium of storage, access, and exchange have affected information design by providing new means of acquiring, organizing, transforming, and presenting data. For the most part, the uses and purposes of information design remain the same—providing structure and form to data to impart greater comprehension in communications across formats as different as news media and scientific publications. Some examples of information design, however, use these qualities of computation for political ends, demonstrating the possibilities of an agonistic information design.

Revealing Hegemony

The visualization *State-Machine: Agency* demonstrates how designers and artists can combine computation with the practices and forms of information design to produce political expressions by rendering data in new ways. Such artifacts and systems of computational information design can be agonistic because they expose and document patterns of association in the construction, maintenance, and exertion of influence in contemporary society. More specifically, they are engaged in an agonistic tactic that I term *revealing hegemony*, which draws on the discussions of hegemony throughout the discourse of agonistic pluralism but specifically in the works of political theorists Ernesto Laclau and Chantal Mouffe (Laclau and Mouffe 2001; Mouffe 2000a, 2000b, 2005a, 2005b).

The concept of hegemony is central to agonistic pluralism. In *Hegemony and Socialist Strategy*, Laclau and Mouffe (2001) build on the work of Antonio Gramsci (1971) to reassess and redefine the concept of hegemony. For Gramsci, hegemony was a class struggle. In his attempt to understand why communist revolutions had not taken hold more broadly, Gramsci theorized that the ideas of the dominant group, in this case the ruling capitalist class, were absorbed by the workers through social structures, including schools and popular media. These social structures lured workers into supporting the capitalist system and ignoring thoughts or actions that would, from Gramsci's perspective, serve them better. Thus, the term *hegemony* broadly describes the way one group develops dominance over another group not by force but by obtaining implicit consent from the subordinate group through social manipulation.

Laclau and Mouffe's work makes two primary contributions to the concept of hegemony. First, they reject the essentialism of Marxist thought present in Gramsci, which defines hegemony from a position of class. Second, they redefine hegemony as an open and flexible discursive

strategy. That is, hegemonic practices freely and dynamically bring together histories, ideas, and intentions from a diversity of perspectives into issue-oriented ideologies.

From the perspective of a theory of an agonistic pluralism, hegemony is not a fixed and final state or an effort with a unidirectional vector (from powerful to subordinate). Rather, hegemony is a flexible and vigorous web of related factors, actions, intentions, and objects that are in constant flux, under pressure from and exerting pressure on a multiplicity of positions. This view of hegemony shifts the agonistic effort away from striving to overcome hegemony and toward participating in an ongoing process of exposing and documenting current hegemonic practices so they can be examined and questioned.

Identifying and making hegemonic forces and their means known is vital to the discourses of agonistic pluralism because it helps people discover and label sites and themes of contention in the political landscape. Likewise, the tactic of revealing hegemony through design provides the basis for further agonistic efforts through design or by other means. *Revealing hegemony is a tactic of exposing and documenting the forces of influence in society and the means by which social manipulation occurs.* Designers and artists can use forms of computational information design to represent and perform the associations and flow of resources between people, organizations, and practices, which structure and exert force in contemporary society. To do so, they use the principal qualities of computation as a medium to produce artifacts and systems that uniquely express and respond to the varied and dynamic structures of contemporary hegemony. Two examples that are examined here are social network visualizations and software extensions.

Social Network Visualization: Charting the Associations of Hegemony

Social network analysis is a research method for investigating the relationships between actors within a social context. This method of analysis can be used to examine any network of social relationships and exchanges. It can investigate patterns of gossip within a high school or citation patterns across an academic discipline. What is central to social network analysis is not the content of the relations and exchanges but rather the process of identifying and representing the structure of those relations and exchanges.

Within social network analysis, the analytic activity and visual form are reciprocal. The method produces a visualization that orders and depicts the relations between chosen social actors in the chosen context,

and it does so in a manner that allows those relationships and various permutations of them to be documented and explored. Social network visualizations are produced by codifying the relationship between actors in the system, marking their connections, and often assigning weights (representative numeric values) to those relationships to denote the strength of the connections between any two or more actors. Various algorithms and software packages can be used to process these relations and produce a depiction of actors arranged in space such that their spatial distribution from other actors and at times the visual quality of the connection to other actors is meaningful to the relationship status under investigation.[9] From the resulting image, a researcher might be able to make claims about strong or weak ties among members, expose connections among individuals or groups that might otherwise have gone unnoticed, or distinguish individuals or groups for specific inter-ventions to disrupt or bolster the strength of the network. Social network analysis and the commensurate visualizations thus lend themselves to the tactic of revealing hegemony because it provides a method and form attuned to charting the associations and flow of resources among people, organizations, and practices.

 They Rule (2001, 2004, 2011)[10] and *Exxon Secrets* (2004)[11] are two projects by Josh On that employ social network analysis and visualization tech-niques to represent the structures and patterns of influence across corpora-tions and other institutions. *They Rule* (figure 2.2) is an online interactive social network visualization that allows users to explore a dataset contain-ing the names of Fortune 100 companies and their board members. Specifi-cally, with this visualization, users are able to produce images that depict the cross-affiliations among board members of Fortune 100 companies. A user may begin constructing the visualization by either company, institu-tion, or person. If a company or institution is selected it appears on the screen and the user can select to view the board members of that institu-tion or company, which appear arrayed around the image of a board table. Clicking on board members then draws lines connecting to all of the other boards they sit on. The user can continue the exploration process with each member. As the image of the network is constructed, the appearance of the board member is manipulated: the more boards that board members sit on, the fatter they grow. Users can also choose to begin with a single person, and then explore the connections between that person and the boards they sit on. In addition to self-directed exploration of the dataset, users can automate the process of finding connections between companies or institutions. By selecting Find Connection from the menu, a user can

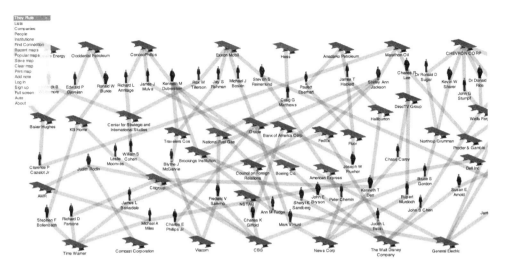

Figure 2.2
Josh On, *They Rule* (2001, 2004, 2011), http://www.theyrule.net. Map created by
user ssackz, on the 2011 version of *They Rule*. This map depicts the relationship
between the oil and media industries and is titled *Oily Media*.

select any two companies or institutions to be automatically searched, and
the software produces a visualization that shows how those two companies
are connected via their board members. As yet another mode of interac-
tion, users can save maps they have created, thereby contributing to an
ongoing archive of documented structures and patterns of connection
between corporate boards.

The social network visualization *Exxon Secrets* (figure 2.3) is built from
the same software code base as *They Rule* but is focused on a different
domain. Sponsored by the environmental advocacy organization Green-
peace (USA), *Exxon Secrets* is a social network application that exposes and
documents the influence of the petroleum company Exxon-Mobil in
shaping climate-change debate, regulation, and legislation. The visualiza-
tions chart the funding that the Exxon Mobil Foundation provides to
researchers, lobbyists, and organizations that are climate-change skeptics
and who question the reality or significance of climate change. The impli-
cation of this visualization is that the Exxon Mobil Foundation uses net-
works of funding to influence the climate-change debate by supporting
research and public relations efforts that counter claims that climate
change is a detrimental phenomenon that is in part caused or exacerbated
by fossil fuel production and use. The purpose of the *Exxon Secrets*

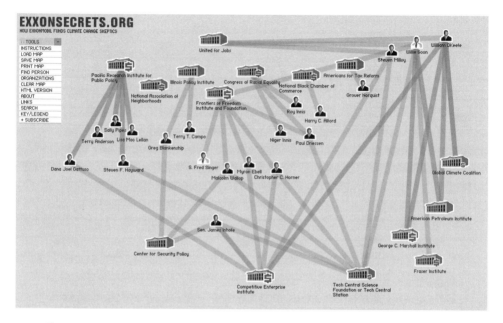

Figure 2.3
Josh On, *Exxon Secrets* (2004), http://www.exxonsecrets.org/maps.php

visualization, then, is to present the complex lattices of financial relations that shape this discourse and action.

The actors in *Exxon Secrets* are scientists, spokespeople, and organizations and are categorized by funding amounts. Instead of *They Rule*'s icons of boardrooms and businessmen and -women, *Exxon Secrets* uses icons of government buildings (overlaid with dollar signs that change in size) and icons of heads (differentiated by gender and role). As with *They Rule*, users can construct network representations either by organization or individual. The user then can show all of the organizations that an individual is connected to or all of the individuals connected to an organization. For each individual or organization, a user can view a panel of detailed information, including background information, notable quotes and deeds, and a timeline of funding received from the Exxon Mobil Foundation. In addition, as with *They Rule*, *Exxon Secrets* includes a set of premade visualizations.

As examples of agonistic computational information design, both *They Rule* and *Exxon Secrets* chart associations among institutions, individuals, and issues, with the implication that these relations form a structure through which influence is exerted. In *Exxon Secrets*, these relations are

complex and involve myriad actors and events that intersect with the subject of climate change. The inclusion of events and organizational details in *Exxon Secrets* is a significant addition to the functionality of *They Rule*. It extends the capacity of the software to reveal hegemony because it allows users to discover patterns of action as they develop and change over time in response to specific issues. By showing how actors, resources, and interests align in variable configurations that are not reducible to simplistic or obvious patterns, the visualization expresses the dynamic and contingent nature of hegemony. For example, with *Exxon Secrets*, users can view and compare the networks of associations formed around "Climate Stewardship Act Attack" with those of the "Global Warming Legislation Attack." With these two visualizations, the arrangements of individuals and institutions across the events can be studied to develop an understanding of the political landscape of climate change generally and around each of these events specifically.

By providing views into the actors and forces involved in a particular issue, *Exxon Secrets* works to represent hegemony as a conglomeration of ideas and intentions from a diversity of sources. Hegemony, so depicted, is not a structure or condition based on class distinction. Instead, it is a condition of associations and attachments to an issue—in this case, to work against climate-change research and associated legislation. This notion of associations and attachments, more so than dividing lines along the class, status, or even political party affiliation, characterizes the contemporary understanding of hegemony. Because of their formal qualities, social network visualizations are particularly suited to provide representations of these connections and orderings of resources to issues. Moreover, by providing simple capacities for interactivity with the visualization, these projects also suggest the potential to use computational media to produce ever more dynamic views into the construction and exertion of hegemony in contemporary society.

Nearly a decade after the first instantiation of *They Rule,* social network analysis and visualizations continue to be used by artists and designers to examine hegemony. However, with changes in the context and capabilities of computational media have come changes in the processes and products of computational information design and its agonistic variants. Creating *They Rule* and *Exxon Secrets* required that On search, locate, and organize the data that underlie the representations, but today such data are more readily available, formatted, and able to be accessed online. An increasing number of tools also automate or at least proceduralize the visual formatting and display of data. From this confluence of factors comes the

mashup—a distinctive practice and form with significance to computational information design.

The mashup as form derives from music and is akin to the remix: it is a combinatorial form made from the blending of preexisting parts.[12] In computational information design, a mashup is data (of any kind) that come from two or more sources and are brought together to produce a new form or functionality. In most domains of computational media, the term *mashup* refers to a Web-based software application that draws on data and presentation layers from two or more digital applications or services to produce a third, distinctive, digital application or service. Mashups often rely on application programming interfaces (APIs), which are sets of access points and exchange techniques that allow a programmer to write software that accesses data from one application or service and passes it to another. The central activity of creating a mashup is using code to suture together data into a new form, and it is made possible by the malleability and interoperability of digital data—the qualities of computational media that enable transcoding.

The visualization *State-Machine: Agency,* discussed at the start of this chapter, is one example of computational information design via the mashup: it draws from a series of online databases and other resources to acquire the data that it combines and then expresses. Another example is Skye Bender-deMoll and Greg Michalec's the *Unfluence* project (2007)[13] (figure 2.4). Like *They Rule* and *Exxon Secrets,* the *Unfluence* project uses a social network visualization and computational information design to reveal patterns of influence across institutions, organizations, and individuals. Like *State-Machine: Agency,* those networks and forces of influence concern campaign contributions. In fact, both *State-Machine: Agency* and *Unfluence* were winners in the Sunlight Foundation's[14] 2007 mashup contest that sought innovative examples of the use of computational media to promote government transparency. What distinguishes the *Unfluence* project from *State-Machine: Agency, They Rule,* and *Exxon Secrets* is the extent to which it draws from other sources and the capabilities it provides for exploration. As an artifact of computational information design, the *Unfluence* project exemplifies a procedural approach to information design and highlights issues regarding the role of the image in evoking the political.

Arriving at the Web page for the *Unfluence* project, a user specifies the state, year, government office (governor, state senate, state house, state assembly, state supreme court), category of people from whom the contributions come (political action constituents and lobbyists, such as accountants, health professionals, conservative Christians, or pro-life activists),

Figure 2.4
Skye Bender-deMoll and Greg Michalec, *Unfluence* (2007), http://unfluence.primate.
net

and a dollar amount (such as greater than $500, greater than $1,000, or
greater than $10,000). The user then clicks on Generate Graph, and a social
network visualization is produced that represents all the contributions to
all the candidates within the specified election and contribution size. Users
can then explore the visualization. Circles representing donors are green,
their size is relative to donors' total contributions. Arrows emanating from
the donor circles mark their connections with the candidates. The circles
of candidates are red or blue, depending on their political party affiliation,
and their size represents the total amount of money received from all
contributors. Pointing at any circle (that is, any candidate or donor) dis-
plays the name of that individual or organization. Clicking on the circle
opens an auxiliary window that searches for and retrieves information (if
present) regarding the individual's voting record or past contributions.

Bender-deMoll and Michalec (2007) describe the process of generating the *Unfluence* visualization by detailing what this design process involves:

A query is generated from your search settings and sent to National Institute on Money in State Politics' API which looks in their databases and returns a list of matching candidates as an xml file. For each candidate we get a list of the top contributors, and discard any with contributions below the value threshold you set. This donor-recipient information is formatted into a network and passed to a program called GraphViz that computes positions for the nodes and draws it (with help from ImageMagick). The image is passed back to you. When you click on a node, we send queries to NIMSP and Project VoteSmart to check if there is information available (this requires some hacked scraping and matching code) for that candidate, and include the links in the info bubble. The visual effects are provided by script.aculo.us.

This description conveys the ways in which computational information design is increasingly a practice of procedurally acquiring, referencing, and combining data. The artifact that results from this process—the image itself—does not exist a priori and is not set in its final appearance by the designer. Instead, the image emerges from and is procedurally expressive of the data and the code written to render that data. That is, the form that the designer provides is not the final form of the image but rather the rules from which to construct the image. This mode of producing representations is characteristic of computational artifacts and systems and marks a point of distinction from other media forms. As Bogost (2007, 4) describes, "To write procedurally, one authors code that enforce rules to generate some kind of representation, rather than authoring the representation itself." In the case of *Unfluence*, even the formal qualities of the image of the network—its so-called look and feel—are the direct effect of the software libraries used.

Varieties of Political Expression

All of these computational information design projects engage with content that is political in nature, and all of them seek to show patterns of financial influence in and across elections, governance, and corporate organizations. These visualizations are agonistic because they provide access to hegemonic conditions, making them seen and knowable. But even within this tactic there are varieties of political expression that can be differentiated.

A social network visualization is not inherently political, but its form *lends itself* to visualizing hegemony because it can represent the relations

between a heterogeneous array of entities. More generally, a visualization is not political or more political just because it employs computation. Although the design of *Unfluence* leverages the principal qualities of computational media more thoroughly than *They Rule* or *Exxon Secrets* does, that does not necessarily make it more agonistic. Indeed, its provocation is arguably less than that of *They Rule* or *Exxon Secrets*. When users view the image of a network in *Unfluence*, there is nothing in the form of the representation that is explicitly contestational. In contrast, consider the images of the networks in *They Rule* and *Exxon Secrets*, where the networks are presented as visually distinctive images that are politicized by means of visual design. The form is manipulated to communicate decidedly politicized perspectives. In the design of *They Rule* and *Exxon Secrets*, On provides visual anchors via icons that give meaning and assign identities to the actors within the network, visually casting those actors in roles that evoke negative connotations and that are unquestionably political. The board members in *They Rule* grow fatter as they join more and more boards, conveying associations to excessive consumption, and the institutions in *Exxon Secrets* are overlaid with larger and larger dollar signs as the contributions they receive from Exxon increase. These anchoring icons in *They Rule* and *Exxon Secrets* leave the user with few doubts about the political positions that are expressed through these visualizations.

Using visualizations to express political positions introduces a bias into the form, thereby distancing these visualizations from their social scientific counterparts that strive to report without prejudice. From an agonistic perspective, the bias in these expressions is appropriate, not problematic. Centrality, or neutrality, is impossible in agonistic pluralism because the broad and divisive differences of positions are considered to be constitutive of the political condition (Mouffe 2005b). *Bias is required to do the work of agonism.* A visualization that is agonistic cannot just present the facts. An artifact of information design is made agonistic by the extent to which it identifies and represents contestable positions or practices. Given that the tactic of revealing hegemony is meant both to document hegemonic conditions and also to rouse and shape future arguments and action, artifacts and systems engaged in this endeavor combine political content with unabashedly biased visual representations that work vigorously as provocations.

Unfluence and the project that began this chapter, *State Machine: Agency*, are both concept works. They are responses to a solicitation for projects from the Sunlight Foundation, and they show how social network visualizations can provide an awareness of the entanglement of money and politics and of the structures and patterns of influence. These projects do

important work as demonstrations, but it is worth noting that *Exxon Secrets* functions as something more. Of the visualization projects discussed so far, *Exxon Secrets* connects most strongly with common notions about the practice of design. With *Exxon Secrets*, an artifact has been constructed for and situated within the context of a project beyond itself. *Exxon Secrets* provides an example of how agonistic information design can fit within a broader political project as a component of communications and advocacy efforts. It shows how social network visualizations can reinforce an adversarial stance between two sides of a political conflict—the climate-change debate. The visualization is called on to do a particular job—to provide evidence for an argument that corporate forces are aligned against climate-change research and legislation. Situated within the Greenpeace organization, the visualization does double duty—as a resource for those already engaged with the issue and wanting to understand more about the influence of these networks and also as an incitement to those unfamiliar with the issue, drawing them in and providing pathways to gather more information or take action through Greenpeace (figure 2.5).

Exxon Secrets also provides an example of how procedurality can support a practice of agonistic information design by enabling the replication of politicized forms across issues. As with *Unfluence* and *State-Machine: Agency*, the project *They Rule* can be considered to be a demonstration because it provides a compelling example of the potential of computational media to evoke the political. This potential is most fully realized when the visualization is used for multiple political provocations. That is, the capacity of procedurality is most acutely evident when On reuses the code base from *They Rule* for *Exxon Secrets,* shifting with relative ease from charting the associations among the boards of Fortune 100 companies to charting the associations between individual corporations and their relations with institutions around an issue. This requires the accessing and parsing of new datasets and the designing of new icons, but the core structure and capabilities remain, carried in the code, and can be applied over and again. This capacity for the procedural transfer and thus repeated instantiation of tactic and form from one contested topic to another is one of the outstanding qualities of computational information design.

Extensions as Interventions

Visualizations are a common and compelling form, but they are not the only form of computational information design. Other forms and practices of computational information design rely less heavily on the image in the

Figure 2.5
Josh On, *Exxon Secrets,* shown as embedded in the Greenpeace USA Web site (2011),
http://www.greenpeace.org/usa/en/campaigns/global-warming-and-energy/
exxon-secrets

familiar sense that visualizations do and thus demonstrate other ways
information design might be directed toward revealing hegemony. One
example is the design of extensions for Web browser software. Extensions
are supplemental software applications that can be installed to run in
conjunction with another core application program, augmenting that
application with whatever functionality is made possible by the extension.
For example, there are extensions that block online advertisements, that
add artistic flourishes to the software's visual appearance, and that stream-
line productivity by assisting in online information management.[15] Most
of the time, extensions are used for simple things, such as adding more
rows to a Web browser bookmarks bar, but there are also inventive uses of
extensions for decidedly political expressions.

Extensions are similar to mashups in that they leverage the capacity for
transcoding: they access data from one application or service and pass it
to another to produce a new functionality. The primary difference between

mashups and extensions is that the mashup constitutes a new application and the extension is embedded in another application. This embeddedness presents an opportunity for design and a variation on the tactic of revealing hegemony. Whereas visualizations are fundamentally about depicting in a graphical manner, extensions can be used agonistically as interventions that both expose and contextualize hegemony. With extensions operating as interventions inside existing applications, the tactic of revealing hegemony is extended and amplified by the ability to *reveal in place*, connecting the exposure of hegemony together with the conditions through which hegemony occurs.

Designed and implemented by Nicholas A. Knouf (2009), the *MAICgregator*[16] is an intervention by way of computational information design (figure 2.6). Short for Military Academic Industrial Complex Aggregator, *MAICgregator* is a Firefox Web browser extension that exposes and contextualizes the relationships between academic research and military funding "to counter the hegemony of the present-day University" (Knouf 2009). The added functionality of the *MAICgregator* that is provided by the extension is not a productivity enhancement or ornament. The *MAICgregator*

Figure 2.6
Nicholas A. Knouf, *MAICgregator* (2009), http://maicgregator.org showing the Department of Defense funding for the University of Southern California in 2009

intervenes in the Web pages of universities located in the United States and provides information about military funding that they receive, with links to external files on the Internet that document that funding and the associations between academic research and defense initiatives. The *MAICgregator* goes beyond depicting the networks of hegemonic forces and provides a reflexive investigation of hegemony. It reveals the ways that military funding, research, public relations, and news media mix together in the contemporary university and contextualizes this revealing within the Web site of the institution under examination. In contrast to visualizations such as *Exxon Secrets*, which provide a view of hegemony from the outside looking at an issue, the *MAIGgregator* provides a view of hegemony from the inside.

After installing and activating the *MAICgregator* extension, a user can visit a university's Web page, and if the school receives military funding, then headlines, short text descriptions, and links to details regarding that funding are inserted into the page. Depending on the settings of the extension, this information may surreptitiously replace the underlying, original content. For example, the news section on a university's home page might be replaced with a new headline "Current Alternative News," which shows links to public relations announcements for military research associated with that institution. By adjusting the settings for the extension, the user can allow images of university trustees to be inserted into the layout of the page, replacing the existing images. In some cases, the replacement of text and image is nearly seamless, with the military funding data and images of trustees being integrated into the existing structure of the Web page to appear as if it was the original and intended content of the page. In other cases, the integration of the auxiliary data is not smooth, resulting in layouts that range from the slightly awkward to the chaotic. In either case, the experience of navigating and consuming the Web with the *MAICgregator* can be disconcerting, as images are replaced with new images that do not quite fit either in scale or style, and links are inserted into pages that unexpectedly lead users off the site to press releases for often obscure research projects.

The *MAICgregator* is yet another example of the procedural rendering of data in computational information design. Here, again, the activity of design is not the authoring of a specific and predetermined representation but rather the authoring of software, composed of rules that, when executed, produce a representation. In the case of *MAICgregator*, the representation attempts to be relatively unexceptional. It is designed to be integrated into a given form—the existing format of an academic Web site. This is

not a trivial design task. To achieve this culling and integration of data requires an understanding of the location and structure of data across the Internet. Knouf and his collaborators detail this process in their project documentation.[17] In brief, the *MAICgregator* searches the Internet for sources of information concerning military funding of academic research and focuses on United States Department of Defense funding. Sources of data include the USAspending.gov database for grants and contracts; the DOD Small Business Technology Transfer program database; the PR Newswire database; the Foundation Center 990 Finder database to locate trustee names; a Google News search for relevant news stories; and a Google image search to locate images of trustees. The design challenge goes beyond locating and retrieving data, however, because the data also must be parsed and correlated. That is, for the data to be transformed into information, they must be identified by type and associated with specific academic institutions. Finally, the design of a given page of an academic institution must be deconstructed so that the appropriate information can be integrated back into that page in the correct places. Integrating all of these processes together makes for the functionality and experience of the *MAICgregator*.

Like the *MAICgregator*, the *Oil Standard* (Mandiberg 2006)[18] is a Firefox extension that integrates auxiliary information into Web pages to document associations and effects within hegemonic social conditions. As with the *MAICgregator*, the issue of concern is grounded in economics, but here there is a shift of focus and content. Created in 2006 by Michael Mandiberg, the *Oil Standard* extension replaces or augments the monetary amounts in any given Web page with their equivalent cost in barrels of crude oil. The extension's name is a play on terms that refers to the gold standard, which grounded the value of money in gold as an objective reference point. This project makes clear that the standard is no longer gold but oil and that the standard is not as objective or at least not as fixed as gold was.

Rather than simply provide the daily cost of oil, a number that is readily available elsewhere, *Oil Standard* transforms the data so that they are more understandable, grounded, and meaningful. Depending on the preferences set by users, either the standard price in U.S. dollars is replaced entirely, or the price in oil is placed next to the standard price in U.S. dollars on all Web pages. This includes the cost of items for purchase on commerce sites and any monetary amount listed on a page. So when the line "$260 billion" appears in the text of a news story regarding national debt, next to it in parentheses appears the conversion of that amount into numbers

of barrels of crude oil. Likewise, when a user purchases a book or mp3 player, the cost of the item is translated into numbers of barrels of crude oil.

Oil Standard engages in another variation on the tactic of revealing hegemony, which extends the act of documenting and can be characterized as an endeavor of *translation*, which is concerned with the invention and expression of equivalencies between constitutive elements of hegemony. With *Oil Standard*, this process of translation begins with the construction of equivalencies between two constitutive elements—oil and money. To this is added a third—objects of consumption (such as the items on Web pages with oil prices associated with them) (figure 2.7). These objects of consumption ground and express the relation between oil and money in a way that enables understanding. In *Oil Standard*, the objects of consumption—whether a paperback book or an mp3 player—operate as the translating elements as they are transformed into equivalencies with oil. Compared to the cost of oil, the perceived value of everyday objects remains relatively more constant over the short term. We have a general idea of how expensive and valuable an mp3 player and a paperback book

Figure 2.7

Michael Mandiberg, *Oil Standard* (2006), http://www.turbulence.org/Works/oilstandard

are. By the conversion of money into oil and then consequently the conversion of the cost of objects into oil, users are provided with a grounding of the value of oil that is experientially accessible and understandable and reinforces the hegemony of oil, into which all things of value can be and are converted.

As examples of agonistic information design, the *MAICgregator* and *Oil Standard* extensions weave together technical capacities and use. On a technical register, they operate by interceding in and augmenting software, adding new functionality and purpose. This intervention occurs at the level of data and code and thus draws attention to the possibilities of a technical, specifically computational, form of expression with political intent and affect. Although extensions are not inherently political, this particular form of political expression would not be possible outside of computational media. It depends wholly on the combined qualities of procedurality, transcoding, and the network as a medium of storage, access, and exchange.

These extensions as interventions are a form of computational information design that is particularly appropriate to expressing hegemony, and they demonstrate the ways in which the qualities of computation can be leveraged to evoke the political. As Laclau and Mouffe redefine hegemony (2001), it is a dynamic and contingent combination of histories, ideas, and intentions from a diversity of perspectives: hegemony is as a constantly changing arrangement of forces and effects. Because of the technical capacities of the extension to aggregate and integrate data in near real-time, it is uniquely capable of documenting and expressing these dynamic and contingent conditions. For example, the effects of *MAICgreator* vary according to research, funding, and news cycles. As university projects develop, receive funding, get promoted through institutional and governmental public relations departments, and are picked up by the news media, the content of the information integrated into a given university's Web page changes. Through the procedural lens of the *MAICgregator*, a given university Web page in September 2010 might appear markedly different than the page would have appeared in September 2009, due to the changing status of funding associations. A similar situation is present with the *Oil Standard*. As the price of crude oil fluctuates, the translated cost of an iPod, a copy of *Pride and Prejudice*, or any other item that appears with a price in dollars on a Web page will also vary. Even though the cost in dollar amounts has not usually changed for these items from one day to the next, their value in crude oil has. In both cases, the technical capacities of the extension produce expressions that reflect the variable constitution of

forces and effects that characterize a contemporary understanding of hegemony. In both cases, computational information design is used to express the persistent interleaving of influence throughout our everyday activities and familiar social institutions.

Extensions as interventions also operate along a register of use. Like other forms of interactive computational media, such as video games, extensions are experienced only when they are run,[19] in this case within the host software of a Web browser. One cannot simply launch an extension and have it return data or information without using the software that it extends. Put another way, with extensions, actual use is required to evoke the political. This is significant because in these cases, the activity of revealing hegemony reflects user actions and the contexts in which users find or place themselves—for example, browsing academic Web sites or shopping online. Because the effects of these extensions are shaped by one's own interests, choices, and actions, the process of revealing hegemony becomes personalized, contextualized to one's self as a consumer of information and goods. Through notions of *revealing in place* and *translation*, which are made possible by weaving together technical capacities and use, the idea of hegemony shifts from a generic notion of external forces —a vague specter—to an experience of hegemony in which users themselves are present as actors. The notion of use adds another dimension of note to agonistic computational information design, and it provides another manner of distinguishing these works—by comparing expressions that represent and those that perform.

Representing and Performing

All of the projects presented in this chapter contribute to a common endeavor of revealing hegemony, but there is a key difference in *how* they do so. To varying extents, they all leverage qualities of the medium of computation to produce representations, but some go further to produce systems that perform the very conditions of hegemony that they strive to reveal. In doing so, they constitute a mode of adversarial design that is unique to computational media and further demonstrates the ways in which computational information design can do the work of agonism.

Projects such as *They Rule*, *Exxon Secrets*, and *Unfluence* produce representations of hegemony: they graphically depict networks of force, influence, and the means of social manipulation. These representations provide illustrations that document the various actors involved in particular hegemonic conditions and allow users to explore variations across those

collections of actors. For example, with the interface elements of these designs (such as menus and check boxes), a user can select different corporations, individuals, or events by which to structure the visualizations. Because the resultant images are procedurally generated, it is possible to produce extensive series and variations of representations with relative ease. With this ability to select among actors and thereby produce different views, the representations begin to provide a perspective on hegemony that aligns with Laclau and Mouffe's notion of hegemony as manifold and multifaceted. Through these representations, users can move beyond understanding hegemony as simply a single-point exertion of force. They are given a view into the constitution of hegemony as a flexible conglomeration of individuals, organizations, ideologies, and actions. They also can analyze the extent to which the particular visual forms of a representation are political—that is, the extent to which they explicitly communicate a contestable position.

Project such as *State-Machine: Agency*, *MAICgregator*, and *Oil Standard* extend the means of graphical depiction and operate in a distinct manner. These projects produce representations but they also perform the hegemonic conditions that they reveal. The hegemonic conditions are procedurally enacted as a user interacts with or makes use of the software.

Consider again *State-Machine: Agency*. The political stance that is advanced through the visualization is performed through the expressive qualities of the visualization. The software that structures the visualization procedurally enforces relations between datasets, visually formalizing and kinetically expressing a relationship between politicians and money. So with the data and the algorithmic structuring of the work and the affordances of interactivity, *State-Machine: Agency* performs this condition of influence in contemporary politics. When interacting with the visualization, a senator's position on the screen is defined by his or her relation to the selected funding sources, and it is impossible to separate a senator from these funding sources. Although a user can click and drag a senator away from his or her funding source momentarily, the circle bounces back into place as soon as the user releases the button, thus procedurally performing a claim about the politician's binding relations to campaign contributions.

Even more than *State-Machine: Agency*, the projects *MAICgregator* and *Oil Standard* perform the hegemonic conditions they seek to reveal by way of their technical format. By integrating with the structure of a university Web site or the activity of consumption—that is, by integrating the project with another context and action—they perform the pervasiveness that is

characteristic of hegemony. For example, when a user casually shops online with *Oil Standard* installed, she ubiquitously encounters the value of oil. As long as the extension is running, there is no escape from the collapse of all values into the currency of oil, thus performing the notion of the influence of oil as being all encompassing. The *MAICgregator* also imbues users with a sense of the sweeping entanglement of academic research and military funding. Both projects also offer an aesthetic strategy of seamlessness that reinforces the pervasiveness of hegemony.[20] As the integration of the information concerning defense funding or oil prices is incorporated—by way of transcoding—into the experience of surfing the Web, it enacts the way in which hegemony operates by efficiently interweaving ideology and influence into social structures and everyday activities.

MAICgregator and *Oil Standard* thus provide demonstrations of how information design and computation might be brought together to construct new forms of adversarial political expression. In these projects, the conditions and constructs of hegemony are literally codified in the design. And moreover, with *MAICgregator* and *Oil Standard*, hegemony is brought to the fore *in situ*. It is encountered in a mediated form that calls attention to itself by both its visual presence and its pervasiveness. Such examples of agonistic information design operate in a manner similar to Bogost's notion of a procedural rhetoric in video games, which "represent how real and imagined systems work . . . [and] invite players to interact with those systems and form judgments about them" (Bogost 2007, vii). Like the video games that Bogost describes, these examples of agonistic computational information design invite users to experience the conditions and constructs of hegemony, develop an understanding of hegemony, and perhaps form judgments about those conditions.

Summary

In his essay "Critical Visualization," Peter Hall (2008, 128) calls on readers to consider visualization as "a creative process concerned with not just the finished artifact but the framing, gathering, connecting and arraying of data" to "imagine it as a critical practice: sizing up and reformulating a terrain of knowledge as well as experimenting with new and alternative forms." This chapter presents examples of such a practice of critical visualization and critical information design that do the political work of agonism. As Mouffe (2005, 25) states, "Mobilization requires politicization, but politicizing cannot exist without the production of a conflictual

representation of the world, with opposed claims, with which people can identify, thereby allowing for passions to be mobilized within the spectrum of the democratic process." One of the tasks of agonistic information design is to provide those conflictual representations of the world. The examples in this chapter depict claims concerning the structure and exertion of power and influence in contested matters such as campaign finance, corporate leadership, policy and the environment, military research, and oil.

If agonism is taken to be an ongoing endeavor of politicizing issues, then revealing hegemony is perhaps the most basic tactic of this endeavor. As a tactic, it works to make conflictual positions better known and better available for contest. When analyzing adversarial design, one question to ask is, How and to what extent does a given artifact or system of computational information design engage in the tactic of revealing hegemony?

Answering that question requires investigating the ways that the forms of information design are combined with the principal qualities of computation to render artifacts that are decidedly political. As discussed, the artifacts and systems of computational information design are particularly suited to revealing hegemony because the principal qualities of computation can be used to express the dynamic and associative qualities of influence and social manipulation. Hegemony, as is discussed here and within theories of agonistic pluralism, is not reducible to class distinctions or unidirectional relations from the so-called powerful to the subjugated. Rather, this reconsidered hegemony extends in all directions. Just as the condition of hegemony is heterarchical, organized through associations to issues, so too should be the efforts to expose and document, represent, and perform hegemony. Computation as a medium provides distinctive affordances for the political expression of hegemony because of its capacity to render large amounts of ever-changing data from many sources and in many formats. In addition, computation as a medium provides users with the capacity to exert choice in the ordering of that data. Through basic interactivity, users can explore and construct displays of one condition or another, producing representations and performances of hegemony that are reflective of the interests, desires, and in some cases, the actions of the users themselves.

One challenge with the tactic of revealing hegemony is to move beyond simplistic forms of demystification, as if the hegemonic condition was unknown. Too often there is an assumption that simply showing or stating something is an important political act. In some cases, this may be true, but it is important to move beyond just raising a general awareness of a

situation. Critical faculties are not needed to discern that special-interest groups and political action committees contribute to election campaigns, that corporations fund research to advocate for policy in their best interest, that universities are entwined with military and intelligence agendas, and that reliance on oil affects all modes and manners of consumption. But the examples in this chapter demonstrate possibilities beyond simply exclaiming, "Hegemony exists!" The examples in this chapter suggest how computational information design might work to delve into and communicate the particularities of hegemonic conditions in novel ways—vividly recording and providing evidence of the associations and flow of resources between people, organizations, and issues, which goes beyond simplistic declarations of the already known.

3 Reconfiguring the Remainder: Agonistic Encounters with Social Robots

Whether they are used for personal care or welding cars, robots epitomize complex engineered systems. They weave together software and hardware; interface, interaction, and industrial design; and mechanical engineering, electrical engineering, and computer science. They employ advanced technologies, appear as and work in diverse forms and contexts, and play a role in popular and scientific histories and trajectories. Robots are, therefore, another notable category of computational objects through which to explore what it means to do design with computation.

However, the technical answer to the question "What is a robot?" is a matter of considerable debate. In computer science and engineering, the answer to the question has disciplinary significance and marks borders between conflicting approaches to operationalizing nontrivial subjects such as perception, affect, and cognition. Much of the debate in defining robots is traced to differing notions of intelligence—which is considered to be a fundamental property of a robot. Scientists from a classical artificial intelligence (AI) perspective generally argue that a robot requires the capacity for symbol manipulation and the possession of a symbolic model or representation of the world.[1] In contrast, those scientists who endorse what is sometimes referred to as "nouvelle AI" generally counter that intelligence is not synonymous with symbol manipulation and that a robot does not need a model of the world, as "the world is its own best model. . . . The trick is to sense it appropriately and often enough" (Brooks 1990, 6). At stake in this debate are the questions of what constitutes or what counts as intelligence and how to construct a computational artifact or system that can be claimed to possess some form of intelligence.

But intelligence alone does not answer the question "What is a robot?" In addition to the attribute of intelligence, physicality is commonly considered to be a fundamental property of a robot. Consider that virtual on-screen characters are referred to as agents, not robots, even though they

may display qualities of intelligence, and yet a physical artifact, such as a toaster or a vacuum cleaner, that displays even rudimentary qualities of intelligence is often referred to as a robot.

In a discussion of design, these qualities can be drawn together in a simple and direct manner to answer the question "What is a robot?" When computational intelligence and the physicality of an artifact are bound together, we have a thing that can be called a robot. This binding of computational intelligence and physicality is significant because it constitutes a kind of embodiment, which structures the possible relations between people and robots. This embodiment makes robots distinctive as a category of computational objects. But the embodiment of robots is not naturally occurring; it is designed. A robot's embodiment is a consequence of how "intelligence" and "the artifact" are purposefully brought together.

There are many types of robots, including industrial robots, military robots, medical robots, service robots, and social robots. Of these, social robots present a fascinating yet awkward set of issues for contemporary design and have novel political concerns attached to them. Social robots are distinguished from other classes of robots by their modes of interaction and their purposes. They are designed to engage in communicative exchanges with people; to serve human needs beyond those of labor or common notions of work; and to operate with individuals and small groups of people in homes, in health care facilities, or out in public. Most social robots exist as not-quite products; as artifacts in a liminal state between academic and industrial research labs and the consumer market. But at consumer-good expositions where corporations exhibit their near future wares, social robots are increasingly present. Designers are exploring and experimenting with new forms and modes of interaction for social robots. These explorations and experiments evoke political issues: the ways in which we design the character of our relationships with social robots reflect and reinforce beliefs about what it means to be social and set trajectories for how we might live together with computational artifacts in an increasingly intimate manner.

As an example, consider PARO, the baby seal therapy robot—one of the few social robots that exist as a commercially available product.[2] PARO is encased in antibacterial fur and designed for physical interaction with humans. It responds to touch, sound, and the presence of others through changes in its body position and by making sounds similar to the animal it imitates. It perceives aspects of the environment and adjusts its behavior accordingly—for example, sleeping when the lights are off. It is also able to learn the preferences of its users over time and move and communicate

in ways that will be most pleasing and beneficial to them. Stroking PARO functions as positive behavior reinforcement, and it will register the last actions it did before the stroking occurred and later repeat them. Likewise, striking PARO functions as negative behavior reinforcement, and it will register the last actions it did before the striking occurred and later will not repeat them. Under the fur of the robot are sensors that monitor light, sound, touch, and the position and movement of objects around the robot. Data from the sensors are registered and processed, and instructions are sent to a suite of motors to move accordingly and to play sounds from a speaker embedded below the fur surface of the robot. Sensors detect environmental factors as they change nearly continuously (people move, shadows fall, sounds increase and decrease in volume), and processing and actuation are repeated over and over, resulting in an exhibition of animation and interactivity.

The name PARO is derived from the phrase *personal robot* and immediately associates PARO with the category of social robots. In fact, PARO is described by its designers as a "mental commitment robot" and is designed to elicit emotional response and attachment from users.[3] For example, one scenario of use for PARO is as a surrogate in animal therapy, functioning in a manner analogous to a service or companion animal by providing cognitive and emotional support. The underlying idea is that users will interact with PARO and develop a relationship with the robot similar to the kinds of relationships developed between people and animals.[4]

PARO is not just a trivial gadget or an obscure technological showpiece. Substantial funding and intellectual effort have been put toward the development of this robot. Interactions with it have been studied from multiple methodological perspectives to ascertain its psychological, physical, and social effects.[5] The research teams at the National Institute of Advanced Industrial Science and Technology, who designed PARO, and others have produced scholarly publications related to the robot.[6] It is also available for sale from PARO Robots, Inc., a corporation developed to move PARO from the lab into the market. By most common metrics, PARO is as real and legitimate as any other new technology product.

The design of PARO provides one set of answers to the question "What might be the character of our future relationships with robots?" The embodiment of PARO, carefully crafted through the design of form, materials, behavior, and expression, structures a particular set of possible relations between people and the robot. In its marketing literature, PARO Robotics, Inc. asserts precisely such a connection between the design of the robot

and the kinds of relationships it is intended to induce (PARO Robotics U.S., Inc. 2008):

Covered in pure white synthetic fur, the built-in intelligence provides psychological, physiological, and social effects through physical interaction with human beings. PARO not only imitates animal behavior, it also responds to light, sound, temperature, touch and posture, and over time develops its own character. As a result, it becomes a "living" cherished pet that provides relaxation, entertainment, and companionship to the owner.

Through such descriptions and the designs that accompany them, the association of terms such as *social*, *living*, and *companionship* to PARO concomitantly defines the robot and redefines these terms in regard to the robot. That is, by labeling the robot as social, we have certain expectations of it and of our interactions with it. At the same time, the label *social* also takes on new meaning in considering computational objects as entities that people are or might be social with.

Reflecting on PARO as a designed thing prompts questions and issues concerning how to use robots and what role should be played by design in shaping our experiences with these computational objects. But PARO is not an example of adversarial design. PARO is emblematic of what would be designed against and of what adversarial design works to question, challenge, or resist. Before proceeding to specific tactics of designing agonistic encounters with social robots, it is worthwhile to examine a bit more the political issues of social robot design.

The Political Issues of Social Robot Design

Science studies scholar Lucy Suchman (2006, 239) draws attention to a set of inherently political concerns with social robots when she states, "For me, however, the fear is less that robotic visions will be realized (though real money will be diverted from other investments), than that the discourses and imaginaries that inspire them will retrench received conceptions both of humanness and of desirable robot potentialities, rather than challenge and hold open the space of possibilities." This notion of retrenching is vivid and should be taken literally to express the ways that lines are drawn and positions defended about what counts as proper and preferred relations between people and robots. One way these lines are drawn is through design—through the making of robots that materialize and enact particular conceptions "of humanness and of desirable robot potentialities." Suchman is not arguing against robots but rather calling attention to the need to examine assumptions within robot design and consider

alternatives. If we want robots as companions, what kinds of companionship do we want to engage in with them? What models of human companionship or sociability are we drawing from and designing into these machines, and are these really the models we want to emulate, or should others be considered and designed for?

The question for design is not whether to engage in social encounters with robots but rather *how* to engage in social encounters with robots. Will the design of these encounters reinforce reductive and staid notions of what it means to be human? Will the design cover over anxieties brought about by such animated technology? Or will the design agonistically engage these concerns and perhaps even suggest new experiences with robots?

Consider the baby seal robot PARO again. Throughout video demonstrations, marketing materials, and research papers, it is presented as an innovative and feasible technological solution to the problem of providing therapy to those in need.[7] But using an animated intelligent machine for personal, mental comfort is not a casual, everyday scenario.[8] This animated intelligent machine imitates an animal that would otherwise rarely come into contact with people. One might expect that the strangeness of the situation would confuse people who were presented with the proposition of interacting with PARO. But the design of PARO mitigates such responses. The seal-likeness of the robot is itself a caricature, more like a child's stuffed animal or toy than an actual creature. The design of the robot (as something cute and docile, with soft fur, wiggling motions, and purring sounds) and the user's interaction with it (as a tactile affair in which users hold and stroke the robot as it sits in their laps) moderates the unusual scenario of seeking solace from a machine. Through its design, PARO, which materializes and enacts one idea of human-robot relations, is made to appear pleasing, advantageous, and relatively without issues.

The question of how people will relate to and interact with robots, however, is an issue. Surfacing this question and exploring the issues that underlie it can be agonistic endeavors in the sense of agonism as an activity of ongoing contest between ideas through which dominant perspectives and assumptions are revealed and critiqued (Mouffe 2000a, 2005b). The design of social robots can be interpreted as a political issue—and as an activity of design with political qualities—because through shaping encounters between people and robots, expectations and norms concerning those relations are established and reinforced. These expectations and norms have lasting effects. As Suchman (2006) notes, they influence research and product development trajectories, which are enforced by

allocations of funding and acceptance in both academic and market settings. The design of social robots also shapes how we understand concepts like care, which may, in turn, affect how we develop other products and services. This issue is addressed at length by another science studies scholar, Sherry Turkle, who has worked extensively with the robot PARO and raises moral and ethical questions concerning social robots that reflect perspectives on what it means to be human and the nature of the human experience. In some cases, these questions have clear political qualities and implications, such as when Turkle asks, "Do plans to provide relational robots to children and the elders make us less likely to look for other solutions for their care?" (Turkle 2006, 2).

This is a different kind of political issue and expression from what has been discussed so far in this book. The political qualities of social robot design are not as immediately obvious as the political qualities of campaign finance or the price of oil. The political qualities of social robot design concern personal relations between ourselves and others and questions about how design shapes these relations. The implications of these issues and the consequences of design lie more in the future than the present, as social robots are still mostly a class of products in development. Addressing the political issues of social robot design is important because it demonstrates how design can be preemptive in its political provocations to engage issues further upstream in the research and development process. The question is, How can design do the work of agonism in the context of social robots?

Designing Agonistic Encounters with Social Robots

Agonistic encounters with social robots work to expose perspectives and assumptions in robot design and make veiled issues and excluded possibilities available for inquiry and critique in material form. Through such agonistic encounters, critical perspectives on human-robot relations are put forth. They thus work to keep open the space of possibilities for design and for our future interactions with robots, allowing for a pluralism of design engagements. I characterize the endeavor of designing such agonistic encounters as *reconfiguring the remainder*, bringing together Lucy Suchman's notion of reconfiguration with political theorist Bonnie Honig's notion of "the remainder."

In *Human-Machine Reconfigurations: Plans and Situated Actions*, Suchman (2006) proposes reconfiguration as a tactic for rethinking the design of computational systems and our interactions with them. Suchman's notion

of reconfiguration is developed from feminist approaches to science and technology studies, particularly those of Donna Haraway, positing that "technologies are forms of materialized figuration; that is, they bring together assemblages of stuff and meaning into more or less stable arrangements" (Suchman 2006, 226). Following from this idea, according to Suchman (2006, 226), "One form of intervention into current practices of technology development, then, is through a critical consideration of how humans and machines are configured in those practices and how they might be figured—and *configured*—differently." This notion of configuration and reconfiguration refers both to the technological organization of the system and to the relationship between people and technical systems.

Increasingly, the design of computational systems and products is as an activity of innovation through configuration. Although some aspects of a computational system may be newly invented, most often design produces a custom arrangement of parts, capacities, affordances, and concept to achieve some desired result. For example, the design of a consumer product such as the Apple iPod can be understood as the configuration of various sensors for gestural interaction, a touch-screen display, hard-drive storage and access, and the concept of mobile personal entertainment. Likewise, the design of PARO can be taken as the configuration of various haptic, vision, and auditory sensors, actuators, fur and the baby seal form, and the concept of therapy. Each particular configuration structures, by design, specific kinds of relations between users and the artifact.

Drawing from Suchman, I extend her term *reconfiguration* to describe an agonistic alternative to the design of computational objects. With agonistic reconfiguration, the object is still designed by a custom arrangement of parts, capacities, affordances, and concept. But it is done in a provocative manner that purposefully deviates from familiar configurations. The agonistic activity of reconfiguration is the combining of components and concepts together in unexpected, exaggerated, or otherwise purposefully atypical ways, which produce disjunctions between expectations, the material artifact or system, and the experience of it. Such provocative reconfigurations are not accidental or arbitrary. Rather, the activity of reconfiguration leverages an understanding of the standards of configuration, both technically and socially. It works by manipulating those standards and addressing what is left out of common configurations, which can be referred to as "the remainder."

Political theorist Bonnie Honig uses the term *remainder* to describe what is expelled in politics. This term refers to the people, practices, and

discourses that are overlooked or written out of institutions, policies, legislation, and theories in the attempt produce a consensus that lacks conflict or disruptive differences. But under every condition and from every political position, something is excluded. As Honig (1993, 5) states, "All sets of arrangements are invariably troubled by remainders." One agonistic endeavor is to identify what has been excluded and ask, Why?, and, How would its inclusion reconstitute a given condition or thing?

This excluded remainder can also refer to the veiled issues and excluded qualities that are overlooked, written out, or otherwise expelled from designed things. *Reconfiguring the remainder is an agonistic tactic of including what is commonly excluded, giving it privilege, and making it the dominant character of the designed thing.* In the case of social robots, rather than using design to hasten the acceptance of a social robot or to settle the question of how people and robots will interact with one another, reconfiguring the reminder gives critical pause to this process of social integration.

Embodiment

A political analysis and critique of social robots could pursue many factors, for instance, form, function, interaction, and experience are the commonplaces of design and design criticism. These factors, however, are surface expressions of the principal quality that makes social robots distinctive as a category of computational objects. That is, form, function, interaction, and experience are outcomes or effects of the design of a robot's embodiment. To understand how embodiment is treated in the design of agonistic encounters with robots—how it evokes political issues and can be interpreted politically—requires first clarifying how embodiment can be understood as a designed quality of an object.

Unlike procedurality, a quality that is easily attributable to the medium of computation, claiming embodiment as a defining quality of robots is difficult because it is often construed as a quality that is distinct to living entities. Theories of embodiment from phenomenology and embodied cognition have woven their way into robotics research through the fields of artificial intelligence and the associated questions about what is required for knowing and acting in the world.[9] Embodiment in robotics is similar to notions of embodiment in philosophy and cognitive science, where embodiment is concerned with the body of an entity and its capabilities in defining being in the world. But within robotics discourse, embodiment is not limited to living entities: it can just as easily be a quality of a nonliving entity.

The particular characteristics and effects of embodiment are a significant topic of research in the field of human-robot interaction. Roboticist Kerstin Dautenhahn is one the scientists at the forefront of this research, and her work is useful for framing an understanding of embodiment beyond living entities. As Dautenhahn and her coauthors state, in terms as equally applicable to a robot or human, embodiment can be characterized as "that which establishes a basis for structural coupling by creating the potential for mutual perturbation between system and environment" (Dautenhahn, Ogden, and Quick 2002, 400). In her research, Dautenhahn has been concerned in particular with embodiment from an experimental science perspective. She has developed a framework for embodiment that can be operationalized and quantified, such that degrees of embodiment might be empirically compared among different entities in different environments, with different capabilities and affordances. From this effort, she has developed a definition to describe the state of embodiment within any system: (Dautenhahn, Ogden, and Quick 2002, 400):

A system S is embodied in an environment E if perturbatory channels exist between the two. That is, S is embodied in E if for every time t at which both S and E exist, some subset of E's possible states with respect to S have the capacity to perturb S's state, and some subset of S's possible states with respect to E have the capacity to perturb E's state.

Even when the goal is not the quantitative measurement and comparison of embodiment, such a definition is useful for reframing common notions about embodiment. Such a definition enables moving beyond the notion that embodiment is a quality limited to living beings. As the variables in the definition denote, embodiment is particular-to-particular structures. Each configuration of a robot establishes a different set of possible couplings and mutual perturbations with the environment. Each environment or entity is likewise characterized by certain qualities and affordances that engage these configurations differently, resulting in a diversity of kinds of embodiment. Extending embodiment beyond living entities alone to include the artificial is significant because embodiment can therefore be treated as a quality that can be shaped and manipulated by design—by the choice and arrangement of particular aspects of the robot, including its hardware; software; capacities for sensing, processing, and actuation; form; and behavioral qualities.

But the form and structure of embodiment alone do not shape encounters with robots. Context must be considered with embodiment. The

meaning of different kinds and experiences of embodiment will be construed based on the broader sociocultural contexts in which the robot is set. The home is not the battlefield; service animals are different from pets; seals are not familiar domestic creatures. So even with Dautenhahn's operational definition, embodiment is far from a reductive mechanistic quality. It is highly contingent. Different configurations or reconfigurations of embodiment produce different human-robot encounters in different contexts depending on expectations and desires in these situations. Recall the design of PARO's embodiment—soft fur, purring sounds, and wriggling motions in response to being stroked. Such a design may be appropriate for the contexts of the home, retirement center, or hospital but not to comfort wounded soldiers on the battlefield.

Since embodiment makes robots distinctive as a category of computational objects, it is a promising site of agonism. Designed embodiments and the subsequent forms, functions, and interactions that run counter to our expectations produce deviations from the norm in social robot design. These deviations result in experiences that challenge the familiar and proverbial in social robot design and expose topics of debate concerning our future relationships with robots. Examples of such designs and encounters often lurk just outside the established fields of interaction design and human-robot interaction. Suchman and others have drawn attention to such examples as sites of inquiry.[10] My intention is to build on those analyses through the frame of agonism to draw out design exemplars of social robots that evoke political issues and relations.

Engineering the Uncanny

Blendie is a kitchen mixer that the user speaks to and that speaks to the user (Dobson 2007a).[11] To interact with *Blendie*, users mimic the sounds made by a common kitchen mixer, and *Blendie* responds with a mechanical rendering of those sounds repeated back to the user, produced by varying the speed of its motor. As depicted in the project documentation,[12] a person approaches *Blendie* and begins to make all variety of grunting and whining machine-like sounds of high and low pitch. This instigates a response from *Blendie* of either fast or slow rotation of the motor, which produces a corresponding whirring sound. Over time, the back and forth of sounds uttered and imitated between *Blendie* and the user begins to suggest a dialog of sorts, albeit a strange one.

In an encounter between *Blendie* and a user, the user begins to transform herself to be more machine-like to elicit a response from the mixer.

Figure 3.1
Kelly Dobson, *Blendie* (2007a)

Adjusting one's modes of behavior to elicit responses from others is common and is fundamental for effective communication. Moreover, people often adjust their behavior to make use of or otherwise interact with machines—for example, slowing one's pace as approaching automatic doors to allow time for the system to note one's presence and respond by opening the doors. What is uncommon and arresting with *Blendie* is the requirement of dramatically adjusting human communicative modes with machines to, in effect, perform machine behavior.

This encounter between a person and a robotic kitchen mixer was designed by Kelly Dobson. *Blendie* is part of a larger body of work by Dobson titled *Machine Therapy*, which "tweaks technological artifacts in order to explore their sensitive and emotional side" (Dobson 2007b). Like PARO the baby seal robot, *Blendie* is designed for therapy. But the purposes and modes of therapy between these two robots are remarkably different. Whereas PARO's therapeutic purpose is alleviating human loneliness and remedying a perceived lack of affective exchange, *Blendie's* therapeutic purpose is the reflective exploration of human relationships with machines. With *Blendie,* the subject of therapy with the device is our relationship with devices. In addition, the mode of therapy advanced by Dobson's design is in stark contrast with that of PARO. Whereas PARO is designed

to elicit and support a placid, soothing experience of therapy grounded in amity as healing, *Blendie* is designed to support a model of therapy grounded in unease and confrontation as the cure—the model of psychoanalysis (Dobson 2007a).

The *Machine Therapy* project is agonistic in that it provides alternate modes of interacting with robots that bring to the fore, rather than mitigate, the tension and anxiety that frequently characterize our relationships with technology. Throughout entertainment media, robots are often used to signal and explore these tensions and anxieties in amplified form. In many film representations of robots—Maria in *Metropolis* (1927), Deckard in *Blade Runner* (1982), the *Terminator* series (1984, 1991, 2003, 2009), the artificial boy David in *Artificial Intelligence: AI* (2001)—the robot is a figure at odds with its identity and our relationship to it. In *Metropolis*, it is seductively attractive yet inhumane and despotic; in *Blade Runner*, it is self-loathing; in the *Terminator* series, it is a brutal assassin transformed into a brutal savior; and in *Artificial Intelligence: AI*, it is a discarded anthropomorphic appliance. Exploring these tensions and anxieties through an object such as *Blendie* continues the tradition of the robot as a kind of reflective other but with an opportunity for interaction unavailable through other forms of media. And although this tradition of the robot as a reflective other exists within the cultural representations of robots (in films, television, and fiction), it is conspicuously uncommon in actual social robot design.

In giving voice to the tension between people and technology, *Blendie* affectively manipulates that anxiety and plays on the uncanny, which is a particularly compelling trope for exploring human-robot relationships because it operates by troubling existing categories of form, function, purpose, and being. In his essay "Das 'Unheimliche,'" Sigmund Freud characterized the uncanny as an experience in which the familiar suddenly becomes strange, resulting in a sense of psychological fear (Freud 2003).[13] Freud explores several instances of the uncanny and the common themes that run through them. One theme is animism and anthropomorphism, or the attribution of lifelike, human qualities to inanimate objects. This theme is still explored today and is found in many films that cross the boundary between science fiction and thriller and present visions of computational systems gone awry. In *The Shaft* (2001), an intelligent elevator is out for revenge, and in *One Missed Call* (2008),[14] mobile phones and data networks are possessed by a malevolent entity. More generally than elevators with a vengeance or malevolent mobile phones, the uncanny can be taken to be the wearing away of the distinction between the real and the

imagined, "when we are faced with the reality of something that we have until now considered as imaginary" (Freud 2003, 150).

The uncanny has also found its way into robotics research, through the notion of the the uncanny valley. In 1970, roboticist Mashiro Mori postulated that as a robot appears more human, our acceptance of it increases. This acceptance follows an upward curve until the robot's resemblance to a human being reaches what is called the uncanny valley—a conceptual space in which the resemblance between a robot and a human are almost identical, and the tension between this difference and sameness is disturbing (Mori 1970). Most often, the uncanny valley refers to the visual appearance of the robot, but it is not limited to the visual realm alone. Mori accounted for a more nuanced notion that extends visual appearance to include aspects of presence, behavior, and interaction—a more robust notion of the uncanny that spans various kinds of embodiment. Although often the visual appearance seduces us into thinking that an object is real or alive, usually other forms of embodiment produce the experience of the uncanny. Consider an example of the uncanny valley used by Mori—shaking hands with a corpse. We expect the hand to feel warm and supple, and yet it is cold and rigid, disturbingly contrary to our notions and personal experiences of bodies. Even though the uncanny valley has just begun to be systematically examined (as much as it can be), the idea has been perpetuated in the robotics community over the past several decades.[15] Generally, it is deemed a place to be avoided in the design of robots, particularly robots intended for interaction with humans, because it is seen as a hindrance to the acceptance of robots.

In the context of social robot design, the uncanny is a theme and sensation that reflects the remainder. What is veiled or excluded by design in social robots is the apprehension, confusion, and anxiety often experienced by people who encounter objects that feign to be something other than they are and that invite interaction with them in a personal, even intimate, manner. From an agonistic perspective, however, the reasons that most researchers and designers attempt to avoid the uncanny can be recast as reasons to induce it. Uncanny encounters with robots produce troubling engagements between intelligent artifacts and people. They prompt reflection on the nature and substance of the relations between people and robots.

What is experienced or witnessed with *Blendie* is a reconfiguration of robot therapy and human-robot relations that leverages the uncanny to produce an agonistic encounter. This encounter is agonistic in that the very anxieties and tensions between intelligent artifacts and people that

are usually smoothed over by design are here, by design, made into the basis of the interaction. Interacting with *Blendie* occurs not through placid stroking, but rather, through an agitated exchange of growling at it, and its growling back.

This reconfiguration is materially and experientially enacted through the design of the robot's embodiment. For *Blendie*, Dobson developed audio sensors and software that were fitted within the housing of a commercial kitchen mixer. The audio sensors monitor and register sound (the noises made by humans as they grunt and whine at the machine), analyze the sound for frequency and pitch, and then translate those qualities of human sound into numeric values that can be used to vary the speed of the mixer's motor, which acts as *Blendie*'s projected voice. This may seem like a simple form of coupling, but it is not simplistic. It demonstrates a sophisticated understanding of how to sculpt embodiment by design through the medium of computation (figure 3.2). As Dobson (2007a, 80) explains:

Blendie works by taking in the sound of a person interacting with it through a microphone and processing that sound on a computer running custom software written in C++. The program computes an STFT (short time Fourier transform) to detect the dominant pitch, and an FFT (fast Fourier transform) of this STFT to look for time-domain frequency modulation. If it detects modulation in a range that has been predetermined as a close human approximation to the rough guttural sound of the blender's motor, Blendie then is given the correct amount of power to allow it to spin at a speed that will produce the same dominant pitch of the person's voice. The power is adjusted using PWM (pulse width modulation) of the AC (alternating current) line supplying power to Blendie. The proper PWM for a given pitch is returned from a large lookup table in the software custom made for the blender. The software can tell a human voice from a blender sound, and thereby can keep Blendie from forever feeding back on itself, because a human imitation of a blender is very different from the sound of the blender itself.

Dobson's design evokes the uncanny by intentionally reconfiguring the standard mode of embodiment from human language to machine sounds. This inverts the common relationship of person to machine, in which the person is (at least theoretically) given prominence. Thus, the design of *Blendie*'s embodiment is a machine-centric embodiment. The basis for the coupling is in machine terms rather than human terms.

This shifting of the basis of embodiment draws attention to a we/they relationship. Within theories of agonism, the notion of a we and a they—of an us and a them—is central to establishing difference and an adversarial stance (Mouffe 2000a, 2005b). Through these categories of difference, distinctions between beliefs, values, and practices are organized and

Figure 3.2
Sketch depicting the design of *Blendie*'s embodiment, Kelly Dobson (2007a)

expressed. The performance or acting out of the relationship between these categories, which is often one of tension, is the conflict that defines agonism and represents the political condition. However, the categories regarding social robot design are notably different. Rather than familiar distinctions of we and they, such as the ideological left and right, liberal and conservative, or pro and anti any given subject, here the we/they is, at least initially, a distinction between humans and machines. The tension that is identified and brought to the fore concerns how we conceptualize what is human and what is machine and how these conceptualizations inform and interact with each other.

But beyond just establishing those boundaries of and interactions between the we of humans and the they of robots, the agonistic endeavor in adversarial design is to investigate and question them as categories with political significance that are open to critique and reinterpretation. The

challenge and opportunity of the uncanny as witnessed in *Blendie* goes beyond questions of whether a thing is or is not human, whether it is or is not alive. In fact, uncanny encounters transform the nature of we/they relations beyond initial simplistic categories of human and machine. Rather than rashly either valorizing those categories or making claims of dismantling them, one should instead consider the qualities that underlie those categories and the permeability between those categories. The political issue of concern for design with social robots is not registering or denying humanness. Rather, the political issue of concern for design is how people and robots are going to comingle.

An Uncanny Affective Companion

As computational systems have increased in sophistication and expanded in use, the fields of interaction design, human-computer interaction, and human-robot interaction have gained ground as important endeavors. These fields focus on the study and shaping of interactions with computational systems, often to understand patterns of use and meaning making in order to design systems that are useful, usable, and desirable. In mainstream human-robot interaction research and design, robots such as *Blendie* can be interpreted as provocations that question the base assumptions of such efforts. Recalling Suchman's (2006) concern about the "retrenching" of desires and imaginaries, such interventions are important because they challenge assumptions about modes of interaction with robots and thereby keep open the space of design possibilities, providing alternative themes for design.

The goal of productivity in the design and use of computational systems is an example of how themes in interaction design, human-computer interaction, and human-robot interaction develop, are materialized in systems, and are challenged and evolve. Much of the practice in these fields is geared toward improving the capacity of systems to enable people and industry to "get work done." Early in the history of the field of human-computer interaction, from the 1980s to the mid-1990s, the emphasis on productivity led to equating interaction with usability and usefulness with convenience and expediency. Productivity reigned as the predominant purpose of interaction design and human-computer interaction, against which research and practice were judged. Since the late 1990s, the singular importance of productivity has been steadily questioned through a stream of research projects and publications advancing alternative themes to drive the design and use of

computational systems.[16] As a result of such efforts, today, *ludic*, *reflective*, and *pleasurable* are common qualifiers and themes against which many systems are judged.[17] This does not mean that the topic of productivity is resolved and that the contest over productivity is completed. From an agonistic perspective, the contest is never ended: one "needs to be always switching positions, because once any given position sediments, it produces remainders" (Honig 1993, 200). As soon as an issue appears to be settled, subsequent issues or positions emerge, and they need to be addressed. As the challenging of productivity has proceeded, it has developed connections with other themes. These provide other issues to be addressed and further sites of agonistic intervention: chief among them in regard to social robots is affect.

The theme of the robot as companion or partner (the terms are often used interchangeably in robotics discourse) is popular in robotics research and product development. Partner robots offer the potential of becoming a significant consumer market, and the robot as companion speaks to popular culture's connotations of robots, making them attractive for marketing and public relation purposes. PARO is one example of such a robot. Another example is the NEC PaPeRo. The name PaPeRo is derived from *partner-type personal robot*, and the robot was designed to be a research platform for personal robots for use in the home. Unlike many academic research robots, PaPeRo appears like a finished consumer product. It is made of plastic, brightly colored, and designed to look cute with gentle bulbous curves and large eyes. Over the course of its development, several roles have been identified for the PaPeRo. One of these roles is as a so-called childcare robot that functions as a companion to children and a partner to parents in the activity of parenting.[18]

With the exception of PARO, few such robots are readily available as products for either individual or institutional purchase. Most companion and partner robots are currently in the research and development phase. Regardless of whether a specific robot such as PaPeRo is used in the near future, its development and suggested use is evidence of a particular vision of the world in which robots and people work intimately together in their everyday lives. Along with this intimacy comes a series of expectations and standards of interaction. The design of these robots advances and materializes that vision for ongoing research and product development. Even though robots such as PaPeRo are not in mass commercial production, they still frame what can be expected of future robot products.

In the early history of computational systems design, there was little consideration of affect, which did not fit neatly with imperatives of

productivity. This perspective has shifted in recent years as discourses of pleasure and play have gained prominence. In the design of companion robots, affect often takes on particular importance because it is assumed that for a robot to be an effective companion, it must take into account emotion. The phrase *affective computing* was coined by Rosalind Picard, a research scientist at the Massachusetts Institute of Technology, and has become something of a catchphrase for projects ranging from emotion models for machines to sensors that read the emotions of people. As Picard (2005, 3) describes her approach to affective computing:

Affective computing includes implementing emotions, and therefore can aid the development and testing of new and old emotion theories. However, affective computing also includes many other things, such as giving a computer the ability to recognize and express emotions, developing its ability to respond intelligently to human emotions, and enabling it to regulate and utilize its emotions.

Affective computing is subject to philosophical debates that are similar to those concerning the nature of human and machine intelligence. These debates of definition influence the replication or simulation of certain qualities in artificial entities. Picard attempts to sidestep this issue by emphasizing the pragmatic ends of affect rather than the ontological status of emotion. In doing so, she reveals a common position in robotics that casts emotion as a necessity for achieving rationality and as a means for improving the productivity of the computational artifacts and systems. As Picard (2000, 280–281) states,

The inability of today's computers to recognize, express, and have emotions severely limits their ability to act intelligently and interact naturally with us . . . because emotional computing tends to connote computers with an undesirable reduction in rationality, we prefer the term *affective computing* to denote computing that relates to, arises from, or deliberately influences emotions. *Affective* still means emotional, but may, perhaps usefully, be confused with effective.

Affect, in the context of robots and specifically social robots, is thus treated as a way of regulating a robot's behavior, as a quality of a machine's expression toward people, and as a way of regulating a person's encounter with a machine. The general idea is that affect, in the form of emotional models, improves the decision-making capabilities of robots and, in the form of expressive gestures, persuasively shapes desired interactions between people and robots.

From an agonistic perspective, this conceptualization of affect begs examination. What, in such conceptualizations of affect, is being left out?

What is the remainder of affect in the design of social robots? What alternative experiences of companionship and affect might be advanced through design?

Omo was created by Dobson in 2007 and, like *Blendie*, is a robot with a novel form of embodiment. *Omo* detects and responds to the breathing patterns of others and can deform its own structure to express breathing-like motions. *Omo* operates by monitoring the breathing patterns of those holding the robot through the use of pressure sensors. At times, *Omo* matches the breathing patterns of its companion; at other times, it offers a new pattern for its companion to match, guiding the user through a series of controlled breathing exercises.

The contrast between *Omo* and other social robots draws into relief some of the developing assumptions concerning the design of robots, particularly the design of robots as companions. Foremost is *Omo*'s form—egglike, glowing, and rubbery (figure 3.3). In contrast to the common design approach to such robots, it is not cute. Its appearance does not mimic a domesticated pet, it is not fuzzy, and it does not have baby face features, such as large eyes. In comparison to PARO, *Omo* appears alien. Even next to robots such as the NEC PaPeRo, which also has a squat rotund form, *Omo* is distinctive in its lack of anthropomorphic or zoomorphic features: it has no eyes and no mouth. In Dobson's (2008) own comments, *Omo* is designed to be more like an organ than an animal or a person.[19]

Figure 3.3
Kelly Dobson, *Omo* (2007b)

Furthermore, the use of breathing as the basis of embodiment—that is, as the source of sensed input and output—enhances the uncanny status of the robot. When robots are given lifelike qualities, it is usually via the common notion of form as shape and volume or the presence of specific anthropomorphic or zoomorphic features. For example, PARO appears life-like because its appearance imitates an animal, and one instinctively anthropomorphizes PaPeRo due to the outline and position of the eyes in its head. To make the foundation of the robot's embodiment associated with the activity of breathing—an activity that is distinctive to living enti-ties and only to living entities—is an uncommon design decision, which results in an uncanny experience of the robot. *Omo's* uncanny-ness, however, does not create distance from the computational object. It draws people closer in what is potentially a much more powerful affective rela-tionship as it calls forth a psychologically complex form of communication and exchange through the experience of shared breathing. As Dobson (2008) describes the interaction with *Omo*, "as you are holding it, you will slowly change with it, much like as you hold another person you start breathing together." Even compared with the tactile interaction of PARO, the breathing together with *Omo* appears strikingly intimate. Furthermore, whereas with PARO the design is an attempt to mitigate any strangeness of the encounter, with *Omo* this strangeness remains; it is indeed the essential quality of the encounter.

Transparency and consistency are commonly lauded as principles of design that make products accessible by way of their predictability. The design of *Omo* seems to run counter to this principle: *Omo* is not regular in its behavior and interactions with others. The robot responds in one way at times and another way at other times. At times, it mimics the breathing patterns of its human companion, and at other times, it makes abrupt and startling changes in its own breathlike movements. As a social robot, *Omo* presents a kind of companionship and affect different from PARO or PaPeRo. Its companionship is not altogether subservient and is designed to include irrationality as a desirable feature, not as the flaw that Picard associates it with in her construction of affective computing. The remainder here is the irrationality of affective experience, and the design of *Omo* brings this often excluded quality of affect to the fore.

Agonistic Reification

Amy and Klara is a robotic system composed of two synthetic speech robots designed by Marc Böhlen (2006a).[20] According to Böhlen, the purpose of

this system is to explore the expectation, construction, and maintenance of norms of public speech and the ways that those norms and our experiences with variations to those norms are affected when transferred to nonhuman entities that are mimicking humans (2006a, 2006b, 2008). This topic of exploration is not unusual in the context of human-robot interaction research. In that field, one can easily imagine social science experiments grounded in some notion of productive communication or cooperation, conducted under controlled circumstances with clear variables, resulting in empirical findings and design guidelines. Böhlen's work is differently situated, however. *Amy and Klara* is an experimental art and engineering project, and as such, the practices and agendas of conventional human-robot interaction research do not need to be upheld. With *Amy and Klara*, expectations of robot communication are explored not in the common form of social interaction but at one of the limits of human communication—cursing. By this exploration of the limits of the social qualities of robots and human-robot interaction, *Amy and Klara* is akin to *Blendie* and *Omo* in challenging our assumptions of human-robot relations, and it provides yet another example of an encounter with social robots that is made agonistic through the design of its embodiment.

The two synthetic speech robots *Amy and Klara* are physically instantiated as stationary boxes that are painted hot pink, equipped with speakers, and that curse at and argue with each other (figures 3.4 and 3.5). One of them (*Klara*) speaks with a German accent. Böhlen's choice of speech and cursing as the basis for these robots presents a critical perspective on computational speech recognition, speech generation, and adaptive dialog. As he explains (Böhlen 2006a),

It is not only the disconnect between a human voice and a box that produces it that can make one feel uncomfortable. It is also what these voices have to say to us. The language of synthetic speech recognition and synthesis systems is a highly selective subset of the full, rich and messy body of linguistic corpora that comprise our oral and written languages. Exclamations are absent, questions are rare and the vocabulary is generally optimized for commerce.

Here the charged world of foul language is under investigation. Swearing offers several interesting conduits into a critique of the under-exposed normative tendencies in automated language representation and social robotics. Why are most smart gadgets and toys friendly and playful, why are they usually modeled as pets or servants? Machines that curse and pick a fight might offer a more realistic preparation for a shared future between machines and humans.

Amy and Klara is agonistic in multiple ways. As is made clear in the preceding quote from Böhlen, the purpose of these robots is to question

Figure 3.4
Marc Böhlen, *Amy and Klara* (2006a)

foundational assumptions of human-robot communication and language-based robot expression. As with *Omo* and *Blendie*, the social character of social robots is being explored—what kinds of communication are assumed proper and privileged and what kinds of communication are not and are thus left out of social robot design. The remainder in this case is cursing or what would commonly be considered abusive, juvenile, petty, or dysfunctional communication. Similar to *Omo*, the remainder with *Amy and Klara* is a mode of expression and interaction that falls outside of the rational and productive directives that tend to drive mainstream social robotics. More than simply documenting and representing issues of social robot design, *Amy and Klara* is a demonstrative, interactive instantiation of these issues.

The design of *Amy and Klara* leverages and explores computational text-to-speech, automated speech recognition, and aspects of computational vision as they figure into the construction of social robots. With *Amy and Klara* the substance of the robots' speech is produced by software that

Figure 3.5
A view of the electronics of *Amy and Klara,* Marc Böhlen (2006a)

accesses and reads online lifestyle magazines. The content from these Web sites is parsed and becomes the basis for the construction of ontologies, or computational models of the world, possessed by the robots. As these linguistic models develop, certain words are given weight by virtue of their frequency. These words become the speech that the robots exchange. But sooner or later, there is a misunderstanding between the robots. When one robot fails to understand the other robot, it might be because it has developed a different ontology and thus is speaking a word the other robot does not know, or it might be because of the distortion inherent in the microphones and speakers, which is exacerbated by the German accent of *Klara.* Whatever the reason for the misunderstanding, "dissent arises and they begin to call each other names" (Böhlen 2008, 211). When one robot detects the foul language of the other, it responds in kind with an utterance containing foul language. These quarrelsome exchanges rapidly increase in intensity. As Böhlen (2008, 212) describes the basic procedural structure of the software regulating the social exchange:

Repeated use of a curse word from scale n leads to the selection of a curse word from scale $n + 1$, provided the following word is recognized as a curse word within a given

time frame (otherwise the aggression levels recede). Since recognition and utterance occur in quick succession, both a low level exchange (when recognition results are poor) as well as a heated escalating fight, if recognition results are positive, are possible.

In addition to linguistic modes of exchange, the design of the robots' embodiment employs a computational vision system that regulates their interaction. Each robot is equipped with a camera that is pointed at the other robot, and the camera's field of view includes parts of the surrounding room. Once each robot has developed its corpus of words, and they have been catalogued and compared, the verbal exchange state is triggered by this vision system, which initiates the dialog when it identifies the color pink (that is, when it registers the presence of the other robot). The vision system of both robots is also able detect the presence of a human, as identified by overall shape. When a human is detected by the vision system, the robots change their behavior by first lowering their voices, curtailing their dialog with one another, and finally asking the people present to leave. So these social robots are designed to be social with each another but asocial with people.

The color pink plays an important role in the design of *Amy and Klara*. On the surface, the color pink serves as a gendering device. Together with the voice and the names, it works to construe the robots as prototypically feminine. But the color pink has another purpose beyond serving as a signifier for human understanding. In robotics, the color pink is often used as a test color for computational vision research. Because of the distinctive chromatic qualities of pink, specifically hot pink, it is commonly used for location and targeting purposes in computational vision. There are, for example, robot demos and competitions in which robots search for pink-colored tags in the environment or on people. The color pink thus does dual duty in the design of *Amy and Klara*. It genders the robot in human terms and is simultaneously a fundamental aspect of a robot-centric embodiment, enabling its vision in a manner that reflects the robot's distinctive sensing capacities.

Like *Blendie* and *Omo*, *Amy and Klara* evokes the uncanny. The primary way it does so is by the content and character of the dialog, which is at odds with the expressive capabilities of the robots. When people hear the exchanges between *Amy* and *Klara*, they do not mistake the dialog as occurring between humans. The prosidy of the speech is dull and dronelike. Due to the processing time involved for one robot to recognize the other's utterance, the timing between the exchanges feels fractured. The German accent of *Klara* amplifies the incommensurate quality of the scenario. Such

an accent is associated with sternness, but in this context, the attempt to imbue the robot's voice with a greater amount of personhood only draws attention to the awkwardness of the technology in mimicking human dialog. The overall experience transforms the line between a human mode of communication and its replication into a fissure.[21]

In addition, Böhlen's framing of the dialog as fundamentally antagonistic is striking. Unlike other social robots, *Amy and Klara* are not designed for companionship or therapy; they are designed to engage in verbal conflict with one another. So even the relatively benign exchange that Böhlen (2006a) provides as an example in the project documentation is disconcertingly at odds with our preconceptions of what and how robots might verbally communicate:

R1: "Hey you."
R2: "Leave me alone." (synthetic German accent)
R1: "What is wrong with you?"
R2: "Leave me alone please." (synthetic German accent)

Finally, the design of *Amy and Klara* also challenges assumptions concerning social robots in another, more fundamental manner: they appear to be robots that exist primarily in relation to one another, with only a peripheral connection to humans. In this way, they confound expectations of social robots as intelligent artifacts that are social with humans. The social qualities of social robots serve primarily as a mode of robot-to-robot interaction, and the robots are social with one another, to the exclusion of humans. This disassociation from humans is made all the more strange by the fact that robots are nonhuman entities that depend on a human mode of communication with each other: they speak to each other. One result of this odd scenario is a further troubling of the common we/they distinctions between people and machines. In the case of *Amy and Klara*, the we and the they are conflated as the robots take on decidedly human qualities.

The design of *Amy and Klara* exemplifies a variation on the tactic of reconfiguring the remainder that I call *agonistic reification*. In what might first appear as a paradox, reification—the process of objectifying a thing—can be employed agonistically in the design of robots to produce encounters that objectify human beings in ways that prompt critical reflection on the processes and effects of objectification. The linguistic content coupled with the ways in which language is handled in the design of *Amy and Klara* provides an example. The use of a German accent to connote sternness plays on stereotypes, which are means of socially objectifying people. But

this objectification extends social construction also to include the technical construction of the robot. The design of the robot's embodiment—the computational rendering of a synthetic voice into a German accent—requires objectifying the synthetic voice itself, making it into an element that can be examined and manipulated. In its original form, the synthetic voice does not have a German accent. The German accent is constructed from what is considered to be a more neutral American accent by procedurally "swapping select vowels and consonants" in the text-to-speech software. For example, "Welcome" is transformed to "¢velk2:m."[22] So Böhlen's exploration of the social qualities of speech (for example, expectations, norms, and stereotypes) is an exploration of the social *and* technical qualities of speech. Indeed, in the design of *Amy and Klara* and arguably all social robots, the exploration of the social depends on an exploration of the technical, in effect, melding these two into a single thing. Through such reciprocal plays on stereotypes, language content, and computational phoneme manipulation, the design of *Amy and Klara* fulfills both parts of the definition of objectify: it transforms a quality or condition into a unit of analysis, and it makes that quality or condition actual—that is, materially instantiated and experiential.

Reification in this case serves the agonistic purpose of highlighting assumptions concerning human qualities and relations and the way that those assumptions are imbued in computational systems. That is, reification is one way of bringing the remainder to the fore. Selecting and transforming a particular quality into unit of analysis provides a means to examine and manipulate that quality or unit.[23] With *Amy and Klara*, dialogic interaction is reified, examined, and manipulated. This occurs through a nesting or layering of objectification. Dialogic interaction becomes reified as cursing, and that particular irrational mode of human speech exchange is reified into a series of stimuli and response mechanisms and procedures, which are reified through the discrete computational manipulation of speech.

As with the prior examples of engineering the uncanny, this agonistic encounter is achieved through the design of the robot's embodiment. But contrary to the prior examples of *Blendie* and *Omo* in which embodiment was a quality of a robot that coupled it with humans, embodiment here is a quality of a robot that couples it to another robot. Even the pink coloring of the robot eludes simple explanation as a means for expressing human gender norms: it functions to enable coupling between the computational objects themselves. Thus *Amy and Klara* extend the machine-centric point of view witnessed in *Blendie* to the point of hyperbole. The

design of the robot's embodiment operationalizes the human as a base form of stimulus. Such agonistic reification can be cast as an ironic but still critical response to concerns about translating human qualities into machines. To use Suchman's term, the tactic of reification performs a kind of "retrenching." This retrenching or performance of reification, however, is done in a manner that is self-mocking and contradictory, as it reduces sociability to a single, bounded feature and then instantiates that feature in robot form to produce an exaggerated effect (or affect, as the case might be). In this case, the irony of *Amy and Klara* demonstrates in material and experiential form the problems of extending machine sociability in human terms, and *Amy and Klara* functions as incitement for reflection—to consider assumptions in designing sociability through robot embodiment. For example, one assumes that one's social interactions with robots will be congenial. Moreover, one assumes that social robots will be social with people. *Amy and Klara* demonstrate that there is no essential basis to those assumptions. There is no technical or social reason why social robots must behave that way. In considering how we will comingle with intelligent systems and the role of design in shaping those experiences, *Amy and Klara* is a test case of a scenario in the extreme. The two robots counter saccharine modes of expression and interaction by privileging the abusive and petty, and in doing so they provide another vector along which to consider the possibilities and limitations of designing sociability into computational entities.

Summary

Social robots offer another opportunity for examining what it means to do design with computation. An analysis of the design of social robots through the frame of agonism provides more examples of how the distinctive qualities of computational objects might be manipulated to evoke and explore political issues. In this case, the quality is embodiment, and the political issue regards future human-robot relations: what will be the character of these relations, and what qualities of the social are privileged or veiled by design? As research and development initiatives forge ahead with visions of social robots for partnership, companionship, and therapy, it is important to pause to consider the base assumptions of those projects. The question of how to interact with robots or other intelligent artifacts and systems is anything but settled. The possibilities for sources, kinds, and effects of embodiment are anything but exhausted. As the examples in this chapter elaborate, an agonistic approach to the design of social robots

looks to embodiment as a means for offering alternatives that keep the space of design and our expectations of social robots open and available to dispute.

Commonly, design is a means to demarcate and advance certain perspectives concerning what is desirable in our present and future. The therapy robot PARO is a case in point, as it materializes beliefs concerning the role of robots in society and the ways we might engage them. But just as design can set boundaries, it can also be used agonistically to disturb those boundaries. This disturbance occurs not by the erasure of lines of difference but by introducing productively disruptive tangents. The robots *Blendie*, *Omo*, and *Amy and Klara* are examples of such productively disruptive tangents. They highlight anxieties with technology, offer new modes of affective and intimate interaction, and bring to the fore assumptions concerning human expression and communication with animated artifacts.

On the surface, the political issues of social robot design appear quite different from the political issues described with regard to information design in chapter 2. Whereas the political issues related to information design were obvious and direct—issues of military funding and academic research, the price of oil, networks of corporate influence—with social robots, they are not. This difference is valuable because it shows the range of agonistic endeavors: adversarial design is not limited to what we commonly consider political issues and certainly not limited to ideological frames of left and right, conservative or liberal. In fact, revealing and articulating the contestable aspects of situations often perceived as nonpolitical is a central goal of agonism because the political is a pervasive condition and the contention that characterizes agonism should occur continuously and everywhere.

Addressing assumptions and expressing alternatives begins to engage what Mouffe (2000a, 2005b) refers to as contingency of the social order— that things could always be otherwise and every order is predicated on exclusion. Moreover, it calls attention to what Honig (1993) terms the remainder—the thing that is excluded. In this case, the "things that could be otherwise" are characteristics of relationships between people and robots. Through the design tactic of reconfiguring the remainder, what is excluded is brought to the fore and made materially and experientially available via the robot's embodiment. The analysis of *Blendie*, *Omo*, and *Amy and Klara* shows that each can be interpreted as critical expressions of the remainders of social robot design, specifically anxiety and the irrational.

Furthermore, these agonistic encounters with robots are also political in that they envisage the possibility of different we/they relations—another core task to agonism (Mouffe 2005b). Whereas in political theory discussions of we/they distinctions are usually construed as distinctions between socioeconomic classes or categories of people, here it is initially construed as the relations between people and robots. But these agonistic encounters with social robots do not settle that we/they relation. The familiar distinctions between the categories of human and robot are not defended or upheld. Instead, the designs of these robots trouble, even confound, the assumptions on which these distinctions are commonly made. This troubling of categories is a base activity of adversarial design because it leads to exposing the remainder and thereby the political issues that inhabit and transect those categories. In the case of social robot design, the political issue is not whether but *how* humans and robots will interact. The agonistic endeavor is not to keep the categories of human and robot separate, but rather to identify and explore how the qualities of those categories might intermingle, and through design, to probe the possible relations between people and intelligent artifacts.

4 Devices of Articulation: Ubiquitous Computing and Agonistic Collectives

At first glance, the *Spore 1.1* project appears to be an ungainly and puzzling assortment of stuff collected together—a small rubber tree that is surrounded by computer circuitry, wires, and tubing, set atop a reservoir of water, and encased within a transparent plastic cube (Easterly and Kenyon 2004) (figure 4.1).[1] What is this all for? The simplest answer is an automated system for tending a plant. But it is also something more. The design of the system includes a wry twist that shifts it from just an automated system for tending a plant to a system or assemblage that provocatively models a series of associations and dependencies and provides another example of how design can do the work of agonism. The tree is a particular plant, not in species but in origin: it was purchased from the retailer the Home Depot. The significance of this is that the tree comes with the guarantee that if it dies in the first year, the Home Depot will replace it free of charge. The design of the system links the survival of the plant to the Home Depot. Each week, the computer collects stock price information for the Home Depot corporation via the Internet. Whether the plant is watered or not is determined by the performance of the Home Depot stock. If the stock performs well, the plant is watered. If the stock performs poorly, then no water is given to the plant. If the stock continues to perform poorly, the plant eventually dies from lack of water and is removed from the plastic cube, returned to the local Home Depot, and replaced with another tree provided by the Home Depot corporation free of charge, and the process begins again.

Spore 1.1 is prototypical of ubiquitous computing (ubicomp). As computational components such as integrated circuits and sensors have become smaller and cheaper, they are increasingly embedded in common objects and scattered throughout the environment. The effect is to imbue the world with computational capacities. So through the design of ubicomp systems, one may encounter objects such as *Spore 1.1* more

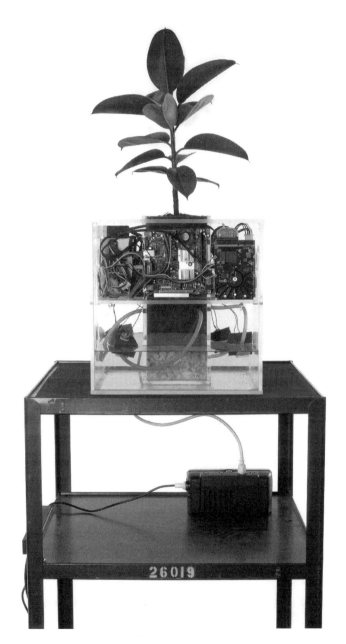

Figure 4.1
Douglas Easterly and Matthew Kenyon, *Spore 1.1* (2007), photo by Luke
Hoverman

frequently—computational objects that are defined by their connectivity to other objects and systems and that have the capacity to receive, process, share, and act on data. One consequence of a world that is imbued with computational capacity is that ideas about engaging computation are progressively shifting. Computation is no longer limited to familiar notions of computers. This, in turn, affects the practices and products of design, opening them to a wide assortment of materialities to manipulate with computation, vastly expanding the possible bits and pieces of computation.

This shift should also provide opportunities for distinctive forms and subjects of adversarial design. As the design of ubicomp systems strings together objects and people in various arrangements of exchange and interaction, in what ways will these designs do the work of agonism? What political issues will be evoked by these novel conglomerations of objects, people, and computation? *Spore 1.1* provides hints at answers to these questions. The project establishes simple linkages between objects of varying scales, to surprising effect. These linkages are made significant in a dramatic way as the life or death of a plant is established as being dependent on—connected to—the relative health of a corporation. Although the design of system is provocative, a political perspective is hard to discern. It could be interpreted in multiple ways, for instance, as being about the cyclic and cynical nature of capitalism and consumption, or the responsibilities of corporations to the environment, or our categorizations of nature and technology. But one would be on dangerous ground to assign any single particular political stance or issue to the project. Rather, *Spore 1.1* should be interpreted as suggesting the agonistic potentials of ubicomp by the way it works to produce an articulation of a corporation, its products, consumers, digital networks, financial networks, and the ties that bind them. By establishing these linkages, the design of *Spore 1.1* creates a collective of sorts that people can participate in to consider and question the components of this system and their relations. It is not so much that *Spore 1.1* addresses any one political theme but that it instantiates a model that expresses all of those themes (and others that one might want to project into it) on a scale that is accessible and able to be experienced. Thus, in a manner that typifies agonism, the design of *Spore 1.1* evokes political issues without resolving them. The design of the system identifies the factors at play and establishes their relationships and possible consequences, but it leaves open the space of interpretation and contest. Moreover, it does so in a manner that leverages distinctive qualities of

computation, suggesting that ubicomp does offer opportunities for unique forms of political expression.

Ubiquitous Computing as a Category of Computational Objects

Ubiquitous computing constitutes yet another category of computational objects with distinctive design challenges and possibilities. In its most basic form, ubicomp is about embedding computation into everyday objects, thereby enabling those objects to sense, process, and respond to the actions of others and the surroundings. When these objects are networked together, they are able to share data among each other, resulting in systems and environments of aware and responsive objects—and making computation ever-present. This has the effect of transforming the experiences of these everyday objects and of computers or computation. It also has the effect of transforming how one does design with computation and provides new topics and tactics for political engagement and expression. Specifically, ubicomp brings to the fore the capability to link together computational objects, and that capability can be used to enact politically provocative associations among people, objects, spaces, and actions.

The origins of ubicomp can be traced to research at Xerox PARC in the late 1980s. There, computers scientists, engineers, designers, and social scientists worked together to explore the possibilities and possible effects of embedding computation into objects and dispersing these objects throughout environments. For instance, one of these early technologies was referred to as "tabs." These were essentially small networked computers that could be worn or carried and that would enable all sorts of interactivity among people, objects, and the environment: "doors open only to the right badge wearer, rooms greet people by name, telephone calls can be automatically forwarded to wherever the recipient may be, receptionists actually know where people are, computer terminals retrieve the preferences of whoever is sitting at them, and appointment diaries write themselves" (Weiser 1991, 80). So from the beginning, ubicomp was positioned as a paradigm of interaction and design that was fundamentally different from familiar notions of using computers. In fact, the discourses of ubicomp are usually framed as a departure from computers as they are commonly known. Ubicomp pioneer Mark Weiser (1991, 94) expressed this sentiment in the opening lines of his canonical article "The Computer for the 21st Century" when he stated, "The most profound technologies are those that disappear. They weave themselves into the fabric of everyday life until they are indistinguishable from it." With ubicomp, this does not mean that

computation goes away but that the predominance of the computer as a discrete object diminishes as computation becomes part of every object.[2] As a result, modes of interaction and experiences with computation shift from those mediated by keyboard, mouse, and screen to new forms mediated by objects such as tables, chairs, picture frames, coffee cups, teapots, and jewelry.[3] This framing of ubicomp as a fundamentally different experience of computation continues today. Phrases such as "ambient intelligence" and the "Internet of Things" work to separate the idea and activities of computing from those beige, silver, or black boxes one thinks of when one thinks of computers and instead prompt visions of computation as distributed, pervasive, and integrated with the stuff of the everyday.

Since the inception of ubicomp the late 1980s, examples of these technologies and their associated capabilities have expanded beyond the walls of research centers as they have become integrated into consumer products. Although ubicomp may not be a common phrase in everyday discussions, experiences with products that suggest the potentials of ubicomp are becoming more commonplace. Consider the Ambient Umbrella,[4] one of a line of products from Ambient Devices, a company that works to bring pervasive information technologies into the home. The Ambient Umbrella is composed of an embedded microchip that receives weather forecasts via a wireless Internet connection and a light-emitting diode (LED) embedded in the handle of the umbrella. Through a wireless connection, the umbrella receives a data feed from accuweather.com, which transmits regularly updated weather information culled from a global network of weather stations and satellites. If the forecast is for rain or snow, the umbrella handle pulsates blue light to warn the owner and remind him to take the umbrella along when he ventures outside. This integration of computational sensing and expressive capacities with an everyday object is relatively simple. But when the umbrella is imbued with these computational capacities, it is transformed from an accessory for keeping dry to a computational information display.

The example of the Ambient Umbrella is useful because it shows how ubicomp combines multiple computational qualities and design practices. As a computational designed object, the Ambient Umbrella is a kind of embodied information design that uses the network as a medium of storage and exchange to gather data and then procedurally renders that data in a physically instantiated form. In combining multiple computational qualities and design practices, new kinds of objects and practices emerge. One might not consider an umbrella a computer, but the Ambient Umbrella is a computationally enabled thing. Thinking of umbrellas or other everyday

objects as computationally enabled things is relatively novel terrain in design. As the technical issues of embedding computation into everyday objects are resolved and the industry practice shifts from engineering challenges to design possibilities, design practitioners and design scholars need to ask, What does it mean to do design with computation in the context of ubicomp?

Connectedness and Collectives

Ubicomp draws from and weaves together multiple qualities of the medium of computation, including embodiment, procedurality, transcoding, and the network as a medium of storage and exchange. But the quality that distinguishes ubicomp is connectedness. By *connectedness*, I mean the capacity of ubicomp to link together objects and systems. This connectedness is of a particular kind. It is not limited to a one-to-one connectivity or to connectedness between same or similar objects. Rather, the quality of connectedness that distinguishes ubicomp is a capacity for one-to-many or many-to-many connectivity among an array of diverse objects.

Consider again *Spore 1.1* and the Ambient Umbrella. Both of these comprise a compilation of dissimilar objects—plants, water, pumps, Ethernet cables, umbrellas, LEDs, and microprocessors. What distinguishes ubicomp is not the form or material of any single object. For example, the tree used in the *Spore 1.1* is materially like any other rubber tree (and could be replaced with any other plant from the Home Depot), and the Ambient Umbrella is like any other umbrella in material and form. What distinguishes these products is their connectedness as objects to other objects and systems—an umbrella to a data feed, which is gathered from a network of meteorological monitoring stations, radars, and satellites; and a plant to an automated watering system, the automated watering system to a data feed, parsed from a more general feed of stock market data, which could be seen as a response to a global financial network of events, actions, and desires.

In both of these examples, the ubicomp system is composed of a multiplicity of assorted objects, which are to varying degrees imbued with computation to exchange and express data. In designing the products of ubicomp, the fundamental activity is one of discovering and establishing compelling modes of computational exchange and expression between objects: the design of ubicomp is the design of connectedness. More than just exchange and expression between objects, this connectedness extends

outward to enroll people, other entities in the environment, and even the environment itself.

Most of the discourses of ubicomp focus on the disappearance of the computer, but I focus here on the emergence of collectives. Computation that is distributed throughout and shared among objects draws people and things together into novel arrangements. These novel arrangements of people and things can be understood as collectives—collections and orderings of exchanges, dependencies, resources, and responses among objects, people, and the environment—focused around a particular issue or activity. More than just establishing connectedness, the design of ubicomp results in the formation of these collectives: the design of ubicomp produces collectives. For some, it may seem odd to speak of collectives comprising both people and object. But this activation of objects and their environments and this mingling of a multiplicity of diverse things together provides ubicomp with distinctive political potential. As designer and theorist Julian Bleeker (2009, 173) puts it, "Whereas the Internet of Non-Things was limited to human agents, in the Internet of Things objects are also active participants in the creation, maintenance and knitting together of social formations through the dissemination of meaningful insights that, until now, were not easily circulated in human form."

Devices of Articulation

If ubiquitous computing is characterized by connectedness and results in the construction of collectives, how does this figure into a discussion of adversarial design? In what ways can these connected collectives function as political provocations, and what political issues are at stake in these collectives? The answers to these questions are found in the notion of articulation. It is my contention that the products of ubicomp should be understood as *devices of articulation*. In the context of adversarial design, these devices of articulation do specific political work: they engage in the formation and expression of *agonistic collectives*. They do so by leveraging the capacities of ubicomp to establish linkages among objects, people, and actions to create open, interpretive, and participatory spaces of contest, thereby providing yet another example of design doing the work of agonism.

This concept of devices of articulation combines the idea of articulation from social and political theory with the more vernacular usage of the term. The common reference point for articulation in social and political theory is the work of Antonio Gramsci (1971), who tied articulation to

class struggle. Just as they did with the notion of hegemony, Ernesto Laclau and Chantel Mouffe (2001) reconsider articulation as a process that extends class struggle and thereby broaden the use of articulation as a theoretical construct. As a general concept in contemporary theory, articulation describes the linkage of discourses and practices to produce hybrid expressions of ideologies and identities. As Laclau and Mouffe (2001, 105) state, articulation is "any practice establishing a relation among elements such that their identity is modified as a result of the articulatory practice." Articulation thus includes a broad range of activities and contexts that extends the common frames of politics and the political. For example, cultural theorist Dick Hebdige (1981) uses the notion of articulation to describe the ways that subcultures form by mixing styles, attitudes, and values between each other and across class boundaries. Whether the example is one of subcultures or political agendas, articulation is a process that creates "chains of significance" (Laclau and Mouffe 2001; Smith 1998) or connections between discourses and practices and that establishes new meaning, value, and consequences among what otherwise would be disparate, perhaps even incongruent elements.

In his research on articulation work in organizations, sociologist Anselm Strauss (1988, 1993) spoke of the mechanics of articulation. This was an apt reference to the most basic conception of articulation—as a quality of physical systems. In physical systems, *to articulate* means to form a joint, and something that is articulated has multiple parts united by flexible joints that allow for movement. A familiar example of articulation can be found in the human arm and hand. In the arm, three joints—shoulder, elbow, and wrist—articulate a series of bones. Each of these joints, together with an assemblage of muscles and tendons, allows for a range of motion. The hand is articulated through fifteen joints and twenty-seven bones that enable grasping and release actions. Taken together, the articulation of the bones in the arms and hand enables a range of diverse activities, including throwing balls, chopping onions, rolling dice, and writing. Remove any one linkage, however, and the possibilities of motion and action change dramatically. Articulation is also used in engineering to describe the design and use of joints to enable movement in any system of parts, usually with the purpose of enabling a particular functionality that would otherwise be impossible. A familiar example of such articulation is the turntable ladder fire truck. To reach fires at great heights, fire trucks need long ladders, and to carry long ladders, the trucks themselves need to be long. But the longer the truck, the less maneuverable it is. To solve that problem, the turntable ladder fire truck was designed to be articulated with a pivot point that

allows the rear end of the truck to be maneuvered separately from the front of the truck, decreasing the truck's turning radius and thereby better enabling the truck to move safely through streets and neighborhoods. The turntable ladder fire truck thus illustrates the central notion of articulation in physical systems as the making of connections between parts, and these connections are significant because they bind together the parts to establish particular capacities and modes of action.

In making the claim for understanding the products of ubicomp as devices of articulation, I am drawing equally from these two notions of articulation. Articulation in physical systems (and specifically in engineering) is not just a metaphor for political articulation. My intent is to merge these concepts and to claim that articulation in the engineering sense can be, by design, an actual instantiation and form of political articulation. As devices of articulation, the products of ubicomp join together, by design, multiple elements in a manner that transforms the identity and meaning of those elements and results in a new object—an articulated collective.

The idea of an articulated collective is partially drawn from the work of Bruno Latour. In *The Politics of Nature*, Latour (2004) develops the idea of the collective as a way of reconceiving relations among human and nonhumans. For Latour (2004, 238), the term refers not to a singular thing, not to *a* collective, but rather to a "procedure for *collecting* associations of humans and nonhumans." This move to bring and bind together humans and nonhumans is part of a larger project of Latour's to reconsider the roles of tools and machines, animals, laws, infrastructure, and the environment—that is, to reconsider the role of things other than people in the construction of facts and society. For Latour, this is important in order to better describe how things get made and done in the world—not by human hands alone but by networks of actors and actants (nonhuman actors) that result in different configurations and experiences of agencies and effects. Articulation, for Latour, is a quality of such collectives. As he states, "We shall say of a collective that it is *more or less articulated* in every sense of the word: that it speaks more, that it is subtler and more astute, that it includes more articles, discrete units, or concerned parties, that it mixes them together with greater degrees of freedom, that it deploys longer lists of actions" (Latour 2004, 86).

Through my concept of devices of articulation, I want both to focus and extend Latour's ideas. First, my attention is on collectives that are the products of design, and more specifically, designed collectives in the context of ubicomp. Second, in addition to claiming that collectives are articulated, I argue that collectives actively engage in the process of

articulation. As devices of articulation, the products of ubicomp both enable and participate in the ongoing endeavor of establishing linkages between elements in the collective. This idea is not foreign to Latour, for whom objects are assertive and actor networks form to enable or thwart all manner of interactions and effects. But the scale that I want to emphasize and explore is that of the collective as a distinct designed thing, which is more than a singular object but less than a network.

With regard to its political potential, articulation is not by definition agonistic.[5] Articulation is agonistic when the product of the articulatory transformation questions, challenges, or offers alternatives to dominant perspectives and practices. Put another way, what is agonistic is not necessarily the process of articulation but the outcome of that articulation—the kind of collective created and the affordances of that collective for experiences of contest. Within the frame of adversarial design, *the tactic of articulation constructs linkages between objects, people, and actions that transform them into an agonistic collective—an open space of contest in which the elements gathered together are able to act out a plurality of conflicting practices, values, and beliefs.* These agonistic collectives extend beyond people and discourses alone to gather together all manner of objects, including plants, animals, software, hardware, networks, tables, chairs, buildings, streets, and cities.

The question of precisely what and how the products of ubicomp articulate is explored in the rest of this chapter. To begin with, although ubicomp systems are in part physical systems, they are not articulated in a manner identical to an arm or a fire truck. Articulation in ubicomp systems is not just the introduction of a physical pivot joint between two objects. Rather, one form of articulation in the products of ubicomp comes through sensors, actuators, software, protocols, and networks. That is, articulation is an outcome of leveraging the qualities of procedurality and embodiment, together with the materialities of the object itself, to provide new functionalities, meanings, and possibilities for action by establishing novel linkages between elements in a system. This provides new opportunities and affordances for doing the work of agonism.

Articulating Actions and Ethics

As issues concerning climate change have become more pressing and more public, new technologies and policies have been proposed and in some cases implemented. One such technology-policy hybrid is carbon sinks and carbon offsets. Carbon sinks are natural or artificial reservoirs of chemical compounds: they sequester carbon from the environment and are

proposed as one form of a carbon offset, with the general idea that production and utilization of carbon sinks might counterbalance excess carbon in the atmosphere, thereby mitigating its effects on the climate. Carbon offsets generally operate on an economic model whereby nations or corporations are allocated a certain number of carbon allowances. When the nation or corporation exceeds its allowance, it must purchase or trade for more. The funds from the purchase of additional allowances are then allocated toward projects that allay the excess carbon production elsewhere—for example, investment in renewable energy, energy efficiency, or the production of more carbon sinks. This notion of mitigating energy use through systems of monitoring and exchange extends from the scale of nations and corporations down to communities and individuals. Increasing numbers of tools and resources exist to calculate and monitor individual and local ecological impact, or one's "carbon footprint."[6] Usually, however, these individual and group systems are designed to focus on the documentation of energy usage or ameliorative actions, and they bypass the political issues and conditions of climate change and control technologies, policies, and practices.

Natural Fuse by Usman Haque (2009) is a ubicomp system that enables users to explore and engage in, on a microscale, the political issues that swirl around carbon sinks, carbon offsets, and the associations of actions and ethics in energy consumption.[7] Through the design of a ubicomp system, it articulates energy consumption, individual desires, and community consequences to produce an agonistic collective that enlists users as participants in a conflictual model of consumption. This model of consumption mirrors the structure of game theory problem of the prisoner's dilemma in the context of energy usage: a limited amount of energy is made available to a distributed group of participants, who must make individual decisions regarding how much energy they will use—decisions that come with consequences to others in the system.

The *Natural Fuse* project consists of a suite of household plants or plant units—assemblages of a plant, sensors, actuators, and software connected together via the Internet (figure 4.2). These plant units are designed to function as carbon sinks and energy regulators. They are plugged into a home electric outlet and operate as a gateway to the electricity from that outlet. Users can plug an appliance such as a lamp into the plant unit to access electricity from the outlet. The appliance can then be turned on and used but only for as much time as matches the amount of carbon offset by the plant. That is, the capacity to use the appliance is modulated by the capacity of the plant to equalize the carbon cost of the using the

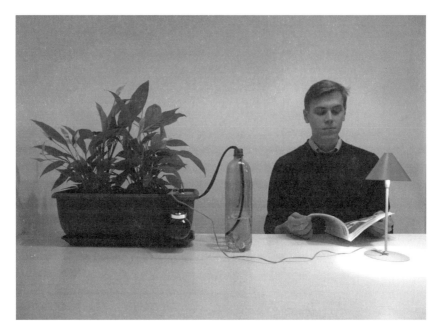

Figure 4.2
Haque Design + Research, *Natural Fuse* (2009)

appliance. This amount of time is extremely short, from a few seconds to a few minutes, depending on the electrical requirements of the appliance.

In the proposed scenario of use, the plant units are distributed among users, who may be close to one another (say, in a single city) or distributed across the globe. A given user comes home and turns on a lamp connected to the plant unit. After a minute or two, the lamp is automatically shut off, having expended its allotment of electricity, and the user faces a choice. She encounters the dilemma.

The plants are connected to each other via the Internet, so each plant unit is a node in a network. By leveraging that connectivity, any user and plant unit can take power allocations from another user or plant unit. Each plant unit is outfitted with a switch marked Off/Selfless/Selfish (figure 4.3). If a user wants to use more electricity than is available from her plant unit, she sets the plant unit to the Selfish setting, and it takes energy allotments from other plants connected to the network. If a plant unit takes too much power, however—if it draws more power than is available in reserve across the network of plant units—then it kills another plant.

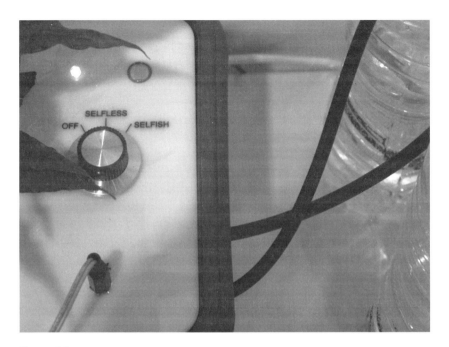

Figure 4.3
Detail, Haque Design + Research, *Natural Fuse* (2009)

As a designed object, *Natural Fuse* exemplifies the general concept of ubiquitous computing: it is a system of multiple everyday objects embedded with computational capacities and networked together to exchange data and interact with one another. If we trace the design of the system, by calling out the elements and their connections, we can begin to understand the connectedness that characterizes ubicomp and how the design of that connectedness can foster the production of agonistic collectives.

Each plant in *Natural Fuse* is instrumented with sensors that produce and monitor data and a microprocessor that manages the plant locally. A photoresistor functions as a light sensor, and a humidity sensor is placed in the soil of the plant. These two sensors provide general information about the status of the plant to the microprocessor. The humidity sensor is also connected to a pump, which is connected to a reservoir of water. A valve on the reservoir opens and closes in response to data provided by the humidity sensor to hydrate the plant. There is also a sensor to detect the power draw from any appliance that is plugged in to the plant unit. The data are registered by the local microprocessor and communicated via the Internet to a central database that logs data for all plants in the

Natural Fuse network. The local microprocessor runs an application that compares the electrical draw from the appliance to the amount of the plant's carbon offset.[8] If the electrical draw exceeds this limit, the local application sends a request to an application on the server requesting more power allocations. The application on the server scans the network of plant units to find available plants to draw power from and sends permission to allocate more power back to the initiating unit, which then opens the circuit to allow the given appliance to power on. If this allocation of power results in the death of another plant—if there is not enough standing reserve of power across the network—then the central application sends an email to all parties involved informing them of the death of the plant. A tally is kept of the number of deaths. Once a plant has reached its three-death limit, a command is sent from the application on the server to the local microprocessor to open a valve on a jar of vinegar attached to the plant unit, dispersing the vinegar into the soil.

As shown by this description, the connectedness of the system extends the computational components of the *Natural Fuse* (figure 4.4). It comprises an articulated collective of people, plants, appliances, electricity, sensors, actuators, microprocessors, software, and vinegar. As a device of articulation, *Natural Fuse* links these elements together in a manner that transforms the individual identity and meaning of each object as it is folded into the collective and transformed. With this transformation, each object acquires new political significance as affordances, dependencies, and responsibilities are established by the design and use of the system. For the appliance to function, it depends on electricity, and the availability of electricity depends on the capacities of a plant unit or a series of plant units. The capacity of the plants to serve as carbon sinks is largely determined by plant biology. The user is responsible for determining under what conditions to allocate electricity to the appliance and when and to what extent to draw electricity beyond the capacities of her plant unit. All of the users in the network link together as a system of both resource and control with finite limits. There is only limited capacity for carbon sinking within the total system, and there is only limited agency available to any one user to make or defend against demands for allocations of electricity.

The collectives of *Natural Fuse* also materialize a series of problematic relations between desires, actions, and consequences and thereby functions as an open, interpretive, and participatory space of contest—and it is in this sense that the collective can be considered agonistic. By leveraging computational capacities for connectedness, the design of *Natural Fuse*

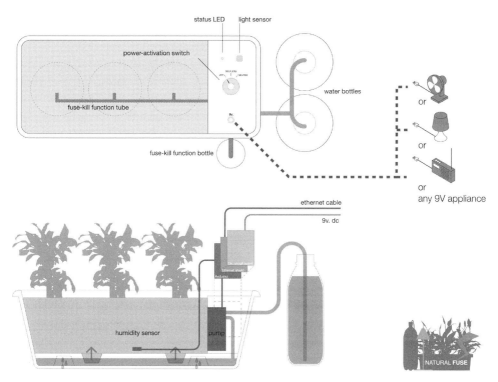

Figure 4.4
System diagram, Haque Design + Research, *Natural Fuse* (2009)

models and allows users to participate in exploring relationships between individual needs and desires and the notion of a common welfare with regard to mitigating climate change. In using the system, the same situation is presented to each participant: Does she take the electricity that she wants when she wants it, or does she find some point of compromise with others, ostensibly for the greater good of all? Does she choose to contribute energy to the collective whole by setting the switch on her plant unit to Selfless, or does she demand energy from others by setting her switch to Selfish? This choice between self-interest and the communal good is the crux of the prisoner's dilemma. But unlike the prisoner's dilemma, the situation is not abstract. It is grounded in a contemporary issue and a specific set of practices—climate change, carbon sinks, and carbon offsets.

Most forms of carbon offsets strive to achieve a state of equilibrium within the system and lead users toward more equalizing behaviors, but *Natural Fuse* enacts an adversarial stance through the design of a system

that is predisposed to disequilibrium. A tendency toward strife is built into the operation of the system. By design, the system enables and almost requires users to engage in contests with one another. In fact, it is not clear whether the counterbalance sought by most carbon sink and carbon offset programs is even achievable with *Natural Fuse*. Each plant unit provides a minimal carbon-sink capacity, and any use of any appliance requires the user to switch to the Selfish mode. In using and reflecting on the use of *Natural Fuse,* one is also prompted, by design, to consider issues of environmental ethics through a micromodeling of the dynamics of resource allocation and the relations between personal desires and actions and the notion of the good of a larger community.

The model and experience provided by *Natural Fuse* is an aestheticized diagrammatic rendering of environmental ethics. The look and feel of *Natural Fuse* make it seem more like an interactive IKEA display than a scientific experiment exploring cooperative behaviors or an engineering prototype for a system of energy monitoring and exchange. But it is precisely this aestheticized quality that lures users into the experience of use, enticing users to participate together with the system in an exploration of this particular issue.

Some may argue that design is more than aesthetics. But the aesthetics of design, in a formal and traditional sense, still have significance in evoking the political. *Natural Fuse* provides an example of the way that pleasing shapes and seductive materials can be leveraged to produce an experience through which an issue is made accessible and of interest by means of a compelling form. With *Natural Fuse*, the user is not asked to pledge alignment to one side of an issue or make sense of cap and trade regulations. Instead, users are invited to take home a curious, seemingly well-crafted, attractive object and use it. The open perspective on environmental ethics that is enacted through *Natural Fuse* provides an outline of the issue that users can fill in with their own actions and interactions and thereby participate in the articulation of the issue through the use of the system.

So, *Natural Fuse* does not take a normative or prescriptive stance on environmental ethics. It does not punish those who consume to the detriment of others, nor does it reward them, nor does it reward those who operate their appliances within the limits of their capacity for offset. Indeed, the openness of the system makes it possible to read a number of potential ethical perspectives into the project. As a device of articulation, *Natural Fuse* gives material and interactive form to a series of relations, highlights the ethical issues at stake, and prompts users to engage—to

participate—in a model of political interaction. It does not resolve the situation of resource allocation and usage. Instead of using design as a means of providing a solution, it uses design to problematize the situation.

Articulating Countercollectives

The *Natural Fuse* project provides an example of ubiquitous computing in the home, but ubicomp is not limited to domestic environment. Urban environments—cities—are also lively sites of ubicomp research and design. In part, this is due to increasing numbers of wireless data networks within cities. In fact, many of the advances and problems of ubicomp have emerged in tandem with the increased availability and capacity of wireless data networks. These networks provide access to various devices that enable the exchange of data between users, devices, and the applications running on them. Although these urban wireless networks provide access, they are not all open spaces. They are regulated and monitored channels of transmission and communication. Whether the access is provided by a municipality or a commercial vendor, the data that flow across the network are subject to the laws and ordinances of the providers, and open to their surveillance. The extent of covert electronic surveillance of network communications is unknown. The notion of electronic surveillance, however, is now part of the public consciousness. We hear about governments that monitor online terrorist chatter, mail that is intercepted in national or corporate espionage cases, and media companies that track, identify, and prosecute those who download or distribute copyrighted materials.

The *Ad-hoc Dark (roast) Network Travel Mug* by Mark Shepard (2009a) is intended to address issues of network surveillance by providing an alternative means of network connectivity and exchange (figure 4.5).[9] This ubicomp system allows users to surreptitiously send short text messages to one another across a closed network, using travel mugs that are input devices, displays, and network routers in disguise. Through its design, the system articulates a collective of resources that enable users to avoid, even momentarily, network surveillance systems without having to forgo the uses of networks for simple social communication.

The functionality of the system is based on a design that, like *Natural Fuse*, illustrates the fundamental notion of ubicomp: at its core, it is a design of connectedness achieved by embedding computational technologies into everyday objects and then networking those objects together. The primary component of the *Ad-hoc Dark (roast) Network Travel Mug* is a common aluminum mug, the kind used to keep drinks warm as one travels

Figure 4.5
Mark Shepard, *Ad-hoc Dark (roast) Network Travel Mug* (2009a)

to and from work, school, or play. What is different about this mug is that it functions as node within an ad-hoc mesh network—a particular kind of digital network in which each node can function as a router, transmitting data to other nodes along the network. As the coffee mugs/nodes move through space, the network changes in size and capacity as users carrying the mugs come into and drift out of range of one another. When enough *Ad-hoc Dark (roast) Network Travel Mugs* are near each other, they form a closed network of data transmission and exchange. This network is "dark" not because it is related to coffee but because it is run as a clandestine parallel network that is outside of the reach of electronic monitoring by municipal or commercial networks.

Each mug is outfitted with a wireless ad-hoc mesh network module, a microprocessor that communicates with other modules via radio frequency (RF), an LCD screen for display, and a microcontroller that runs the necessary software for establishing and maintaining the network and providing basic output via the screen. Software on the network module and microprocessor sends out a repeating signal via RF, which announces its presence and availability to other modules. It also listens for the same signal as it comes from other modules. When one module detects another, a connection is established, and when enough connections are established, a network is formed that allows the transmission and reception of data. When one module leaves the configuration and is no longer within range

of any other module, the network registers that module as unavailable and routes the data among the remaining available modules. In addition, a button embedded on the side of the mug picks up tapping sequences by users. These taps are procedurally transformed into alphanumeric codes, which are transmitted to other mugs within the network, enabling a basic messaging system.

The *Ad-hoc Dark (roast) Network Travel Mug* is part of a larger project by Shepard titled the *Sentient City Survival Kit* (2009c), which uses design to explore the possibilities and consequences of ubiquitous computing in the city. For this project, Shepard has created a series of concept designs and working prototypes. Each concept and prototype offers a novel experience with ubiquitous computing and engages issues of "privacy, autonomy, trust and serendipity in this highly observant, ever-more efficient and over-coded city" (Shepard 2009c). The notion of sentience that Shepard uses to frame his project highlights the ways that computation as a theme is intertwined with contemporary discussions of the city. This is not surprising. Cities have always been shaped by and reflexively shaped technology, from the Roman aqueducts and arcades of Paris to the highways of Los Angeles and Atlanta. Today the city as a "networked society" and as "spaces of flows" is influenced by the qualities of computational technology.[10] The space, place, and experience of the city are now shaped by information and communications technologies infrastructure and services, from cell towers to Internet cafés. New topologies of a city can even be based on degrees of data access and data service usage. Likewise, the qualities of the city reflect back on technology research and design, evidenced by the invention of phrases such as "urban computing" and "urban informatics," which apply perceived qualities of the urban to computational media, products, and services.[11] In such design domains, distinctions are made in the design of computational systems for use in the city versus the rural, suburban, or exurban.

Just as with the data networks themselves, the physical space of the contemporary networked city is a space of pervasive monitoring. In fact, nowhere has the idea of the networked city been more fully realized than in systems of urban surveillance. Networked communications surveillance of the kind that the *Ad-hoc Dark (roast) Network Travel Mug* seeks to counter is one such mode of surveillance. But perhaps the most common mode is video surveillance using charge-coupled device (CCD) cameras—digital systems that produce images without the use of film or tape, usually recording the image data to hard drives. In their simplest forms, contemporary networked surveillance systems combine hundreds or even thousands of

CCD cameras distributed throughout a city to provide a glimpse of the city as a whole and a record of the city to be searched and referenced. So pervasive is this surveillance that in some cities, such as London, it is unusual for people to be out of the view of a CCD camera. More advanced tracking and monitoring systems use a variety of sensors to produce finer-grained data and a heightened awareness and documentation of the city. For example, the ShotSpotter Gunshot Location System recognizes and locates gunshot sounds by using a network of audio sensors distributed throughout the city.[12] Through these and other distributed sensing systems, the city becomes a feed of digital data as sounds, air quality, traffic flow, and other factors are observed, registered, and recorded. The data can be used to initiate real-time responses or be stored and analyzed to serve as the basis for some action in the future.

As these monitoring and tracking systems continue to be developed, they will continue to affect how we perceive and live in the networked city. Geographer Stephen Graham has theorized this confluence of technology and urbanism since the 1990s, and his work is influential in the cultural studies of ubicomp and design. In "Sentient Cities: Ambient Intelligence and the Politics of Urban Space," Michael Crang and Stephen Graham (2007) theorize that society may be moving toward a notion of "anticipatory" cities. In an anticipatory city, sensors and video cameras are distributed throughout the urban environment and are combined with data-mining and pattern-recognition techniques so that users can predict the behaviors of individuals and groups of people.

Shepard himself references Crang and Graham in his *Sentient City Survival Kit* project (Shepard 2009c), and his *CCD-Me Not Umbrella* (2009b) can be taken as an attempt to address and counter pervasive video surveillance and the use of computational vision systems as part of that surveillance.[13] The *CCD-Me Not Umbrella* is a standard umbrella with an array of infrared LEDs studding the umbrella canopy, powered by a stack of batteries housed in the handle (figure 4.6). These lights are not there to illuminate the environment but rather to distort the scene as it is perceived by CCD cameras and to confound the computational vision algorithms that are used for object detection in surveillance systems.

Imagine that users want to avoid CCD surveillance, either because they have something to hide or perhaps because they oppose the practice of surveillance. As they walk down the street carrying the umbrella, they turn the umbrella lights on and off repeatedly. This generates visual effects that are perceptible only to CCD systems (distortion in the captured scene) and frustrate the process of object detection, thereby thwarting effective

Figure 4.6
Mark Shepard, *CCD-Me Not Umbrella* (2009b)

surveillance. A single person equipped with a *CCD-Me Not Umbrella* could thus counter individual monitoring, while a crowd of users with *CCD-Me Not Umbrellas* might compound the effects, resulting in images of city streets that are nearly unrecognizable (figures 4.7 and 4.8).

Although the *CCD-Me Not Umbrella* is not a computational artifact, it is designed to interface with a computational system—that is, as a component of a ubicomp system, albeit a disruptive component. Its design is based on an astute understanding of the technical capacities and limitations of computation and the ways that other objects and their qualities (such as LEDs and the infrared wavelength of light) might combine to work together with or, in this case, against computational technologies. As a common feature of computational vision systems, object detection and tracking uses algorithms to read an array of pixels in a digital image and from that reading identify and follow particular shapes. Through these systems, it is possible to isolate individuals from a crowd, distinguish among people, automobiles, and buildings, and even track and analyze facial expressions, gesticulations, and gait. The array of infrared LEDs in the *CCD-Me Not Umbrella*, however, would frustrate many algorithms used

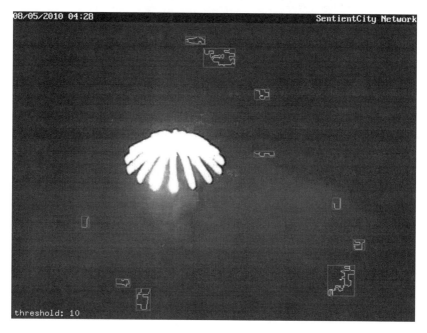

Figures 4.7 and 4.8

Mark Shepard, *CCD-Me Not Umbrella* (2009b). These images show a computational vision system attempting to monitor the umbrella. The umbrella is progressively disrupting the image so that the person is no longer singled out. The software is confused and is tracking light traces in the image.

within these systems. Repeatedly turning on and off the infrared lights could affect the registration of pixels that are stored in system memory and that separate the foreground (the individual who is surveilled) from the background. As a result, the computational vision system would lose track of the individual because it would be unable to separate him or her from the total scene.

As a device of articulation, the *CCD-Me Not Umbrella* produces what I call a *countercollective*—a collective that operates in a manner contrary to another collective. For example, the capacities, resources, and qualities brought together in the design of the *CCD-Me Not Umbrella* work to undo the capacities, resources, and qualities of many advanced video surveillance systems. In this way, countercollectives exemplify and engage in a particular task of agonism that Mouffe (2007) refers to as "disarticulating the existing order." In both a discursive and a material sense, countercollectives work by unhinging the joints that bind another collective together. In doing so, the countercollective disables or thwarts the capacities of that other collective. The collective produced by the *CCD-Me Not Umbrella* is articulated for the purpose of disarticulating the collective of the surveillance system. This notion of articulating a countercollective provides one more example of the distinctive political potential of ubicomp that is made possible by leveraging qualities of connectedness and the interrelated dependencies that characterize connectedness.

Just as a series of dependencies can be traced through *Natural Fuse*, so too can the unhinging or disarticulation be traced through *CCD-Me Not Umbrella*. This unhinging can be understood as a series of dependencies undone by the design of *CCD-Me Not Umbrella*: the light emitted by LEDs on the umbrellas makes the video collected from the cameras unreadable by the computational vision systems, and thus the computational vision systems are unable to provide the monitoring and tracking they were intended for. The *CCD-Me Not Umbrella* thus provides an example of an agonistic encounter between systems or collectives in which one collective does the work of agonism by attempting to disarticulate another collective. Returning to the dual notion of articulation as both an engineering and political endeavor, the *CCD-Me Not Umbrella* exemplifies articulation as something more than just a discursive maneuver. The disarticulation that the *CCD-Me Not Umbrella* attempts to perform occurs on a material level by leveraging the material design qualities of one collective against the material design dependencies of another. Here articulation in the engineering sense is also an instantiation and form of political articulation.

The Pluralism of Collectives

Ubicomp systems employ more than computation and the affordances of individual objects such as coffee mugs and umbrellas. There is a pluralistic quality to these collectives. These systems extend outward to draw in and combine a much greater breadth of people, technologies, and objects than might be initially thought. Through articulation, the design of ubicomp systems link and incorporate the material and social environment into collectives. Through this, they become essential elements of the design. To fully realize the political potentials of ubicomp requires recognizing the extent of this social and material enrollment and the ways that ubicomp systems can provide novel spaces for agonistic expression and engagement.

Consider again the *Ad-hoc Dark (roast) Network Travel Mug* and the *CCD-Me Not Umbrella*. Both of these systems depend on elements and phenomena that extend beyond the obvious parts of umbrellas, coffee mugs, LEDs, and microprocessors. The design of the *Ad-hoc Dark (roast) Network Travel Mug* includes more than the instrumented travel mug. The design also includes the subway car, the habits and customs of morning and evening commuters, and the spatial arrangement of people in that space and at that time. This collection of factors is foundational to the design of the system and requisite for the system to operate. With the *Ad-hoc Dark (roast) Network Travel Mug*, to establish a network among nodes, the nodes must be present and near each other—that is, the system requires particular spatial arrangements. Subway cars provide a bounded space in which that arrangement can emerge. But more than just the material construction of the subway car, the design also leverages the conditions of use of the subway—the close distribution of people within subway cars during the morning and evening commutes. Taken together, these qualities of the subway car and commute provide the material and social infrastructure of use and experience. A similar pattern can be seen in the design of the *CCD-Me Not Umbrella*: its design includes an umbrella studded with LEDs, city streets, and the software that it works to disrupt. Even the weather figures into its design, since weather is the excuse for using the umbrella.

In both cases, elements and phenomena of the social and material environment are made into integral aspects of the systems. They are articulated by design into the systems. Recognizing that ubicomp collectives articulate a host of elements into their design, beyond the computational objects themselves, provides important insights into how ubicomp can do the work of agonism. Like any manner of articulation, the combination of

constituent elements transforms their identity in the production of a new collective with new possibilities for action and meaning. As previously noted, what makes a collective agonistic is the extent to which it produces an open space of contest where conflicting values and practices can be acted out. These spaces of contest are the contexts of use that are transformed by agonistic articulation. That is, when designed or interpreted from an agonistic perspective, ubicomp products can transform the context of use into places and events in which political contest might unfold.

For example, with the *Ad-hoc Dark (roast) Network Travel Mug* and the *CCD-Me Not Umbrella*, riding in a subway car during the morning commute and walking on a rainy city street are no longer just moments spent traversing the city. They become places and events for engaging, challenging, and providing alternatives to urban life as it intersects with ubicomp. The subway car and the commute become a context in which to work around systems of surveillance and engage in parallel, "dark" modes of communication. Likewise, the rainy city street becomes a context in which to work against systems of surveillance and engage in minor acts of disruption. And with *Natural Fuse,* the domestic environment and everyday activities as banal as turning on a lamp become transformed into places and acts in which questions of energy consumption are experientially confronted and the simple act of using an appliance is politicized, made into a situation with political meaning and consequence. Although the previous qualities and associations between these elements and phenomena remain—the subway during the morning commute is still a crowded place, rain is still wet, appliances still require electricity—through the articulation by design, new political associations and possibilities are constructed.

One effect of broadly articulating the material and social environment is that the situations and actors of the political are greatly expanded. By including elements and phenomena of the social and material environment into the design of a ubicomp system and as part of an agonistic collective, those elements and phenomena become politicized in ways they were not before. Who would have previously considered a subway car a space for engaging issues of network surveillance or a houseplant a thing for engaging issues of energy consumption, and individual actions and desires? Computation and the visions and practices of ubicomp seem to amplify the potential for political engagement with objects by enabling them to be linked to and link others into associations that have political meaning and significance.

In this sense, ubicomp systems actively participate in articulation, drawing together and giving new meaning to the constituent elements of

a system, regardless of what those elements are. The ubicomp system engages those elements and phenomena, connects them through a series of design dependencies and exchanges of data and, in the process, transforms them toward new ends. And there seem to be few limits to what can be articulated into a ubicomp system. Nearly any site or object of any scale can become a site or object politicized by design by leveraging the quality of connectedness provided by ubicomp. Just as ubicomp embeds computation in everyday objects distributed throughout the environment, so too can it, by design, draw out the political in everyday situations and practices.

At its core, articulation is a transformative activity, and with ubicomp systems, that transformation is enacted, in part, beyond the designer and the user. Ubicomp systems actively gather, order, and express beyond the actions and intentions of the designers and users. The transformative event of articulation is not solely assigned to human actors. In this way, we are returned to or at least turned toward Latour's project of broadening the understanding of how action happens beyond human effort, taking into account the capacities of objects.

This design of connectedness that characterizes the design of ubicomp also returns us to and mirrors earlier discussions of procedural authorship. With procedural authorship, designers construct rules for representations, those rules are executed in software, and depending on the variables (including user input) and the data available, different representations result. The adversarial design of ubicomp is similar, but rather than producing representations, it produces spaces for contest. With ubicomp systems, the designer constructs a series of linkages leveraging multiple qualities of computation, including procedurality and embodiment, and when those linkages are enacted, depending on the actions of users and the qualities of the elements articulated into the design, different experiences result. In regard to political expression, this suggests that a set of conditions can be gathered together, but the message itself cannot be easily scripted. Indeed, this is the opportunity of adversarial design in the context of ubicomp—to set stages and provide props for the open exploration, perhaps even discovery, of the political significance and meaning of social issues and conditions.

Summary

Ubiquitous computing provides yet another example of a category of computational objects with distinctive design challenges and opportunities for

doing the work of agonism. Doing design with ubicomp means establishing and structuring the connectedness of the constituent elements of a ubicomp system. The range of these elements is arguably boundless because in the grand vision of ubicomp set out by researchers, any object can be imbued with computational capacities and distributed throughout any environment. In the near future, aware and responsive networked objects and spaces will create environments of seemingly sentient things, which will interact with people and with each other in lively fashion. Regarding the political, ubicomp systems have the potential to do the work of agonism through processes of articulation by using the quality of connectedness to construct agonistic collectives. These collectives are political and agonistic because they enable users and objects to participate together in making, exploring, and contesting alternatives to a wide variety of societal issues and conditions.

Although the design of contemporary commercial ubicomp systems, such as the Ambient Umbrella, begins to fulfill the early promises of ubicomp by imbuing everyday objects with computation, most such examples are still relatively staid designs. The collectives they construct continue and extend familiar and common relations. For example, with the design of the Ambient Umbrella, all that has occurred is that two points in a series of relations and dependencies have been combined: news of inclement weather is now available through the object used to mitigate inclement weather. Users do not have to listen to weather reports to learn this information and then reach for the umbrella; they can reach for the umbrella when it communicates news of the weather. This is clever, perhaps even useful, but it is not really a compelling demonstration of the possibilities of ubicomp for prompting new relations between people, objects, and issues and for instigating new forms of action. Moreover, the design of the Ambient Umbrella does not address the political issues or potentials of ubicomp. One function of systems such as *Spore 1.1*, *Natural Fuse*, and the products of the *Sentient City Survival Kit* is to demonstrate alternatives to the mainstream practices and discourses in ubicomp design and product development. As demonstrative alternatives, these products operate in a manner similar to the robots discussed in chapter 3. They function as exemplars of things, situations, opportunities, and consequences that might be. Like Kelly Dobson's *Blendie* and *Omo* (2007a), which challenge us to reconsider the assumptions and purposes of social robotics, projects such as *Spore 1.1*, *Natural Fuse*, and the *Sentient City Survival Kit* challenge us to reconsider the contexts and implications of ubicomp. Across all of these cases, these designed objects do more than just level a critique. They

provide a material demonstration of possible alternatives and shift debate from a discursive format to an experiential form. With *Natural Fuse*, users are not abstractly arguing about the ethics of energy consumption, cooperation, and conservation but are participating in a model of it. And with *Blendie*, users are not discussing robots and emotion at a distance but rather directly engaging a machine in an affectively charged encounter.

In fact, articulation can be considered to be a tactic that is akin to reconfiguration but with distinctions of scale. As a tactic, articulation tends to work across a range of objects that are greater in difference and distribution than is the case with reconfiguration. In some cases, this span of distribution and difference is merely a matter of definition of what constitutes an object or a collective. For example, a challenging boundary case would be a collection of robots working together, perhaps as a swarm working toward a singular goal, or perhaps a group of robots that work together with scientists and a host of other devices, such as the Mars rover robots. But more often, this difference of scale is immediately apparent. For example, *Blendie* consists of an instrumented kitchen mixer and single user, but *Spore 1.1* spans from the individual consumer to the multinational corporation, from the biological health of a single plant to the economic health of the Home Depot.

Perhaps most significant for both the design scholar and the practicing designer is to understand that through the process of articulation—by forging connections between objects, people, space, and actions—the identities and meanings of each element are transformed. A plant is not just a plant, a coffee mug is not just a coffee mug, an umbrella is not just an umbrella. Through design, they are now objects that people can use to engage in questioning and contestation to provoke and probe political issues and relations. This transformation extends beyond the objects to include the social and material context of use and user. A user is now a politicized actor. In these agonistic ubicomp systems, the user engages in questioning and contestation as she decides what amount of electricity to use at what time, whether to participate in the construction of a parallel data network or in the disruption of surveillance systems, or whether and how to intervene in the care of a plant. Through the design of agonistic collectives, one can begin to envisage ways in which users are not only witnesses to adversarial design but also participants in doing the work of agonism.

5 Adversarial Design as Inquiry and Practice

Throughout this book, I have presented examples of adversarial design, including software that reveals the entanglement of military and university research programs, social robots that curse at one another, and umbrellas that counteract surveillance systems. Each of these illustrates how design can do the work of agonism. These artifacts and systems are adversarial because they represent and enact the political conditions of contemporary society and function as contestational objects that challenge and offer alternatives to dominant practices and agendas. They exemplify a series of tactics that can be used to do the work of agonism—revealing hegemony, reconfiguring the remainder, and articulating collectives. Coupled with these tactics are computational qualities that provide distinctive affordances for doing the work of agonism, highlighting what it means to do design with computation, and moreover, what it means to do political design with computation.

So far, I have drawn distinctions between categories of objects, computational qualities, and tactics. I have highlighted what is particular to each and described how design can do the work of agonism. In this final chapter, I briefly extend the idea of adversarial design in two directions—as a kind of inquiry and as a practice. These two directions should provide material for ongoing scholarship into adversarial design and outline how adversarial design could be taken up by practicing designers.

Adversarial Design as Inquiry

Inquiry, like design, is a familiar term but generally a hazy endeavor. American pragmatist philosopher John Dewey provides insight into the purpose of inquiry, which helps explain adversarial design as a kind of inquiry into the political condition. For Dewey, inquiry is a process directed toward situations that are vague and lack a clear sense of meaning and

effect. Dewey (2008, 105) uses the terms "uncertain, unsettled, disturbed" to characterize these situations. As Dewey states (2008, 104), "Inquiry is the controlled or directed transformation of an indeterminate situation into one that is so determinate in its constituent distinctions and relations as to convert the elements of the original situation into a unified whole." Simply put, the process of inquiry provides clarity to muddled situations. And the purpose of providing clarity is to enable action. The outcome of inquiry should be an understanding of the significance and consequences of a situation so that one can better make decisions about or otherwise act on that situation.

With an eye toward describing adversarial design as a kind of inquiry into the political condition, I build on Dewey's work and offer the following: inquiry is a process of skilled examination and reconstruction that renders problematic situations sense-able. The terms *skilled* and *sense-able* are both important here. Inquiry is a *skilled* process because to engage in analysis and synthesis requires competencies of thought and action. By *sense-able*, I mean that the process of inquiry makes problematic situations able to be perceived and experienced. So the process of inquiry makes what Dewey (1954, 126) calls the "expanded, multiplied, intensified, and complicated" aspects of a problematic situation apparent and known and thereby better able to be addressed and acted on.

Another way to describe this, using more designerly terms, is to say that the process of inquiry *gives form* to problematic situations. Through the process of inquiry, the elements of a situation are discovered, analyzed, and synthesized into a new whole—a coherent object or event that has a perceivable structure and significance. To say that the process of inquiry gives form to problematic situations is meant literally. The process of inquiry produces a distinguishing shape and substance to something that is otherwise vague.

Through the process of making contestational objects, adversarial design is a kind of inquiry into the political condition. Political conditions are quintessential problematic situations. They are comprised of a diversity of actors and objects, each with multiple agendas and effects, which often seem incongruent. Adversarial design as inquiry provides a way to express and experience an otherwise confusing situation. Consider again the domain of social robots. As discussed, social robots bring together a wide range of technologies, actual and imagined functionalities, engineering practices, beliefs about what constitutes sociableness (some of which are informed by science), and over a century of cultural history and expression. To use Dewey's terminology, the situation of social robotics is

uncertain. Evidence of this uncertainty is found within the discourses of robotics itself and in the multiplicity of conflicting claims about what social robots are, could, or should be. The political issue of social robotics—What will be the character of human-robot relations?—seems vague. Moreover, the associations and connections between the constituent elements of robotics—those technologies, functionalities, practices, beliefs, and expressions—are disjointed. It is difficult at first glance to comprehend, much less comment or act on, their meanings or implications.

As a kind of inquiry into the political condition, adversarial design provides order to this mess of factors. Adversarial design draws out and instantiates the political issues of social robots in material form. And through a process of synthesis, it produces a sense-able organization to them. For example, the tactic of reconfiguring the remainder identifies what is included and excluded in the design of an artifact or system and then communicates the implications of those decisions by designing objects that invert assumptions and exaggerate the excluded qualities. Through the design of robots such as Kelly Dobson's *Blendie* and *Omo* (2007a) or Marc Böhlen's *Amy and Klara* (2006a), those inclusions and exclusions and their implications are made sense-able. The design of each of these robots gathers various factors of social robot design and synthesizes them into lucid forms, which make it possible for those who encounter them or who consider their use to recognize and appreciate the issues and implications of social robots.

So adversarial design gives form to political conditions. This means that designed objects can provide something literally to point at with regard to the political condition: they can be manifestations—expressive encapsulations—of some aspect of the political condition. This manifestation could be a robot, a visualization, a ubicomp system, or any other designed thing. More important than any specific format is that there be a form at all and that there be an object to consider. When working with computational technologies, this object is often more than a representation.

By leveraging computational capacities, these designed things can be objects that enact a political issue and that allow people interact with them in ways that are politically meaningful. The Web browser extensions *MAICgregator* (Knouf 2009) and *Oil Standard* (Mandiberg 2006) exemplify this notion of enacting an issue through use, performing the issues of hegemony in military research funding and oil as users surf the Web. Usman Haque's *Natural Fuse* (2009) is another pertinent example. It binds together a network of dependencies and effects and allows us to engage in a model of the political issues and consequences at play with regard to energy

consumption and resource management. Each project can be seen as providing substance to political issues. As a kind of inquiry in the political condition, these projects transform the messy elements of a situation into an object and an experience that allow one to sense it and make sense of it.

Adversarial Design as Practice

So far, I have emphasized the use of adversarial design as a way to engage in an interpretation of objects and as a kind of inquiry into the political condition. In both of these activities, the crucial task for the design scholar is to discover and explain the political qualities and potentials of the objects of design. But one could also consider that agonism might be useful as a generative frame for design as a way of shaping a proactive political practice. In such a practice, doing the work of agonism would be an explicit intent of the design.

Considering agonism as a generative frame shifts us to considering adversarial design as a process. In this process, the tactics of adversarial design—revealing hegemony, reconfiguring the remainder, and articulating agonistic collectives—become places along a continuum of a practice.[1] Although I have not treated them as such in this book, each of the tactics could be viewed as informing and leading to the next. The first tactic, revealing hegemony, would consist of identifying and documenting structures and patterns of power and influence in contemporary society. Insights gleaned from this could then be used as part of an assessment of the agendas and desires that are being either privileged or excluded, thereby informing the tactic of reconfiguring the remainder. This remainder could be folded into the third tactic of articulating an agonistic collective— designing a participatory space of contest in which those structures and exclusions might be experientially encountered and challenged and alternatives offered. At each stage, the conceiving and making of artifacts and systems would play a role in providing demonstrations of political issues and conditions, making them known and actionable, providing fodder for the next course of action.

Adversarial design as an intentional practice of inquiry into the political condition moves political design beyond awareness raising and critique. Both awareness raising and critique are important aspects of political dialog, but design can offer something more. Design can produce a shift toward action that models alternative presents and possible futures in material and experiential form. This provides a foundation for examining

and reconstructing political conditions as they are and also for imagining the political conditions that might be. Mark Shepard's *Sentient City Survival Kit* (2009c) hints at this kind of design that results in a literal reconstruction of a political condition. Projects such as the *CCD-Me Not Umbrella* (2009b) and the *Ad-hoc Dark (roast) Network Travel Mug* (2009a) do more than raise awareness and critique. They instantiate a possibility for another ordering of sociotechnical structures that allows us to act in the world in a different way. These projects make possible, at least in model form, ways to work around surveillance while remaining within a networked culture. Here, the value of an engagement with the medium returns. Shepard's projects include working prototypes. Their technical implementation demonstrates that such devices and such alternatives of action are possible. These prototypes are things in the world that instantiate ideas, and they cannot be denied on the grounds of being implausible. Particularly in our contemporary culture that highly valorizes technology, they command attention because they work. It is unlikely that the *CCD-Me Not Umbrella* and the *Ad-hoc Dark (roast) Network Travel Mug* will ever become commercial products. But this does not diminish their potential capacity as demonstrations of what could be. Just as engineering and computer science demos pave the way for future product features and capabilities, we could imagine adversarial design as a class of demos that sets a course for future political actions and conditions that are experienced and enacted through products and services.

The value of designerly form also becomes apparent in this notion of providing believable models for future actions and conditions. The importance of leveraging aesthetics and expressing product-like qualities is amplified in artifacts and systems such as robotics or ubicomp, where the opportunity for most people to engage in their use is limited. Often, in the domain of technology research, design, and development, what is publicly presented and experienced is documentation of the artifact or system—not the artifact or system itself. In some cases, this is documentation of the prototype products in action. For example, documentation of Shepard's countersurveillance *CCD-Me Not Umbrella* includes video footage taken from a staged (but real and working) CCD camera, which demonstrates the artifact's capacity to disrupt a computational vision system that is attempting to track a fictional user. But even in this case, the documentation is partial, suggestive, and built on narrative. With this project and other projects that rely on documentation as their primary public form, conventional design skills and strategies take on special importance.

Without the opportunity to engage in actual use, the user is an audience to the presentation of the design. A vital factor in the success or failure of a given design is the capacity of the documentation to draw the audience into a compelling consideration of use. The design challenge is to provide viewers with a persuasive suggestion of what the use of the artifact or system might be like, so as to enable the viewers to experience the documentation *as if* they were using the artifact or system. This is a challenge that the conventional methods and forms of design are particularly suited for because much of design is precisely the endeavor of communicating the potential experience of use. Even within the realm of consumer products, the purchase of a product often follows some form of staged demonstration of its capabilities that suggests what it would be like to use it.

Perhaps one reason that critical design has garnered attention is that those engaged in critical design tend to be expert product designers. They understand how technologies become goods and services and possess the skills to portray plausible and often tempting expressions of possible products. For example, Anthony Dunne and Fiona Raby's project *Is This Your Future?* (2004), developed for the Science Museum in London, explores near-future scenarios in which people personally produce biopower. One concept presented includes raising and then sacrificing rats as sources of energy for home appliances. To explore and express this concept, Dunne and Raby produced a series of product models, photographs, and even a manual that instructs future users how to avoid becoming emotionally attached to these sacrificial pets. Despite the outrageousness of the idea and the abject nature of the content, Dunne and Raby produced concepts that were believable as products and aesthetically alluring. Such combined use of visual representations and physical prototypes to communicate the potential of use is one example of the ways that the conventional methods and forms of design practice are employed to do the work of agonism.

Limits to a Practice of Adversarial Design

Some might differ with my claim that an entanglement with the professional practices of making products and the formal aesthetics of design can be of value to doing the work of agonism. It is fair to ask if trading on aesthetics is a problem because it flirts with an exploitative aestheticization of the political. As cultural critic Thomas Frank elaborates in his essay "Why Johnny Can't Dissent" (2004), conflict and difference, particularly

in the pop material and visual trappings of clothes, music, and literature, are not the sparks of a revolution but the seeds for harvesting "the next big thing." Perhaps the same could be said for adversarial design. Adversarial design does trade on the appeal of aesthetics. But does this negate or diminish its political potential? My answer to that question is no. However, it challenges design scholarship to adopt a more fluid notion of the political that does not hinge on unduly romantic ideas of radicalness, revolution, and oppositionality.

Doing the work of agonism through design is not a practice that is oppositional to design or technology as general domains. The visualizations are not antivisualization, the robots not antirobots, the ubicomp products and systems not anti-ubicomp. Many of the designers, artists, and engineers who are involved in the conceptualization and making of adversarial products and services are entrenched within and often deeply committed to these technological domains and their development. In a manner that echoes the basis of agonism as a political theory, these artifacts and systems may be adversarial toward the discourses of these fields and the ways in which those discourses are materially instantiated, but adversarial products and services do not work to destroy their fields. For example, it is not that robots such as Dobson's *Omo* or *Blendie* or Böhlen's *Amy and Klara* make assertions that there is something essentially inappropriate or otherwise wrong with robotics as technical or sociocultural pursuit, but rather that robotics could and perhaps should be differently ordered and pursued and its assumptions, perspectives, and trajectories shifted.

Moreover, those objects characterized as adversarial are not radical or revolutionary in the commonsense notions of those words. Too often, terms such as *adversary* and *contestation* are associated with the radical and revolutionary. And too often, things that are labeled *radical* or *revolutionary* are tied to romanticized notions of struggle or of social structures and processes that assume unified and solid positions of left and right or pro and con rather than the dynamic forces and structures that more aptly characterize the contemporary political condition. To speak of these designed objects as revolutionary or radical in the historical sense would be a gross overstatement and flawed. Adversarial design is a theme and set of tactics, and it is inherently pluralistic and can be applied across the political spectrum and issues. But it makes no promises of upheaval. It would be a mistake to universally characterize adversarial design as revolutionary or radical because that would set expectations beyond the scope of these projects.

The Challenge of Judging Adversarial Design

Because of its relationship to politics, there is a pressure for judgment about adversarial design. The effects of design for politics can be measured, so it seems as though it should be possible to measure the effects of political design. If not, then what are the purpose and consequence of adversarial design? These are fair enough points, but design for politics and political design are distinct affairs, and their differences affect the ways in which they can be judged. Design for politics is a comparatively simpler domain for judgment than political design because its goals are clearer and its metrics more obvious. A researcher interested in the effects of design applied to politics can conduct a range of observations and empirical analyses and thereby make claims concerning the efficacy of specific designs, which might even be able to be extended to design more generally. For example, AIGA Design for Democracy's ballot and election design project has conducted research that shows that changes in the design of ballots and polling place signage can help people understand and act on the ballot, as measured through methods of usability testing (Hewitt 2008). Design for politics—situations in which design is applied to improve the mechanisms and procedures of formal governance—can thus be held to claims of affecting specific mechanisms and processes of governance.

Political design, however, cannot be empirically evaluated in the same ways as design for politics. This book has outlined a set of tactics and themes by which we can better describe and analyze political design. These themes and tactics provide the grounds for judging political design. As stated in the beginning of this book, designed objects that do the work of agonism should be judged first and foremost on their contestational qualities. That is, the tactics and variations on the tactics—such as revealing hegemony and revealing in place, reconfiguring the remainder and agonistic reification, or articulating agonistic collectives and countercollectives—provide both qualities of contestation for description and analysis and also for judgment. So one basis for judgment is how and to what extent a given designed artifact or system achieves those tactics. For example, one can examine visualizations to determine their capacities to do the work of agonism. Do they assume identifiable political stances and communicate specificities of hegemonic structures? Do they produce representations or enactments, and if enactments, to what extent do these enactments involve the user in a reflective experience of their own place and role within these hegemonic structures? Or one can examine the ways in which ubicomp

systems provide opportunities to participate in probing, challenging, resisting, or embracing issues. Do they leave open the space of contest, or do they project particular ethical codes and positions into the space of contest? Do they activate new spaces for political engagement and expression, transforming through articulation the political meaning and significance of objects, environments, and actions?

Adversarial Design as a Participatory Practice

Designed things can do the work of agonism or be a kind of inquiry with an emphasis on the qualities of the object itself. But yet another tangent to adversarial design builds off the idea of design as a participatory practice. As a participatory practice, adversarial design would engage with groups and communities and use design to collectively and collaboratively explore the political condition and express political issues. Through this practice, adversarial design could become a new way of fostering public political action.

Both the introduction to this book and chapter 4 on ubiquitous computing and articulating agonistic collectives provide hints of adversarial design as a participatory practice. For instance, Jeremijenko's *Feral Robotic Dogs* (2002–present), suggests a participatory practice of adversarial design in which the designer or artist works with others in the use of a technology for political ends. As people work with Jeremijenko to hack and release the robotic dogs to detect toxins, they themselves become involved in taking political action and participating in doing the work of agonism. One notable aspect of the tactic of articulating agonistic collectives is that it involves and transforms others and their actions into political expressions. By using products that politicize the everyday, the user participates in political expression. Someone who uses Shepard's *CCD-Me Not Umbrella*, for example, might be considered as engaging in a kind of political direct action by working against a surveillance system. And to use Haque's *Natural Fuse* is to engage in a politicized interaction with others, collaboratively exploring the issues of energy consumption and resource management. However, participation is not the essential aspect of those projects and a participatory practice of adversarial design would need to go further still. In those examples, the user is not the instigator of the political action, and there is a distinct separation between the activities of design and the activities of use. Although this format succeeds as one kind of adversarial design, it is worth exploring whether there are other, more participatory ways that this work might be done.

Practices of participatory design offer insights into how such a shift in adversarial design might unfold. These practices are concerned with opening the design process beyond the experts and including those who might be affected by the designed thing in the activities of imagining, conceptualizing, and creating products and services. Historically, the practices of participatory design have been overtly political. The origins of participatory design in Scandinavia are interwoven with union politics and the rights of workers to participate in the structuring of their work environment. In contemporary participatory design, theories of agonism are beginning to appear and be proffered as useful frames for understanding new kinds of political action through design. Scholars Erling Björgvinsson, Pelle Ehn, and Per-Anders Hillgren (2010, 48) have recently drawn on Mouffe and notions of agonism to discuss how the processes of participatory design result in the making of "agonistic public innovation spaces" that enable the public expression of dissensus and foment debate through the activities of design. As I do in this inquiry into objects, Björgvinsson, Ehn, and Hillgren use agonism as an analytical frame for the activities and outcomes of participatory design. In the same way as extending adversarial design from an analytic to a generative frame for the making of objects, we can also imagine agonism as a generative frame for participatory design. Central to participatory design is the construction of methods and tools for eliciting and supporting engagement in the design process. These methods and tools have focused mostly on products and services for workplace settings. But we could also consider the construction of tools and methods for eliciting and supporting a participatory approach to adversarial design.

The lessons learned from this discussion of adversarial design can inform a participatory practice of adversarial design. Each tactic could be employed in a collective and collaborative manner. And as a process of inquiry, these could be taken up by both designers and nondesigners. The outcomes of that inquiry, which include the identification of issues and the constituent elements of an issue, might be markedly different with the participation of a public than when undertaken by a designer alone. One consequence of such a collaboration could be a broadening of the range of political issues and relations engaged through design, providing more sites and subjects for contestation.

One of the characteristics of all of the projects discussed in this book is a clever use of computation as a medium. This relies on deep knowledge and often expertise in the manipulation of computational technology. This is not something that could be immediately expected from a novice public.

In addition, many examples of adversarial design leverage an expertise in the making of products and the use of formal aesthetics as a strategy for luring people into the consideration of use. This too would not be present in a novice public. These are reasons to imagine participatory adversarial design differently, not reasons to abandon its pursuit. Part of a participatory adversarial design might then include educational programs that work to develop a level of technological and design fluency in participants. Or a participatory adversarial design could develop a new aesthetic that engaged speculation but without being spectacular or could focus on constructing publics rather than making objects. All of these possibilities merit further attention.

This question of how to imagine adversarial design differently is an appropriate topic to end with because it exemplifies a core tenet of agonism—that new sites and practices of contestation must always be pursued and that contestation never ends or is resolved. As Mouffe (2005a, 807) states, "To think politically is necessarily to abandon the dream of a final reconciliation and to discard the idea of a public space oriented to consensus. What democratic politics requires is a fostering of a multiplicity of public spaces of agonistic confrontation."

Doing adversarial design and using design to do the work of agonism require a similar perspective. If we abandon the notion that any one design will completely or even adequately address our social concerns or resolve our social issues, then adversarial design can provide those spaces of confrontation—in the form of products, services, events, and processes—through which political concerns and issues can expressed and engaged. To do adversarial design is to embrace a commitment to discovering and inventing ways to express and enable productive dissensus and contestation.

Notes

Chapter 1

1. For documentation of the *Feral Robotic Dogs* project, see http://www.nyu.edu/ projects/xdesign/feralrobots, accessed November 20, 2010.

2. For an overview of critical design, see Dunne and Raby (2001). For overviews of tactical media, see Garcia and Lovink (1997) and Raley (2009).

3. For example, Web sites such as UNESCO's Design 21: Social Design Network (http://www.design21sdn.com), WorldChanging (http://www.worldchanging.com), and Design Altruism Project (http://www.design-altruism-project.org) chronicle contemporary social design and establish informal and formal networks of resources and practitioners. The +Design program, run by ICOGRADA (International Association of Graphic Design Associations), is an initiative by a professional organization that encourages designers to find design solutions to social problems. (All Web sites were last accessed December 1, 2008.)

4. For key texts by Jürgen Habermas and John Rawls and on deliberative democracy, see Bessette (1994), Elster (1988), Habermas (1989, 1993, 1996a, 1996b), and Rawls (1971, 1993). For a review of these texts and positions in regard to agonistic democracy, see Mouffe (2000a).

5. For an overview of the AIGA *Design for Democracy* projects, see http://www.aiga .org/design-for-democracy, accessed January 24, 2010.

6. For documentation of the *Million Dollar Blocks* project, see http://www .spatialinformationdesignlab.org, accessed January 24, 2010.

7. The self-published books *The Pattern* and *Architecture and Justice* as well as project documentation for the *Million Dollar Blocks* are available at http://www .spatialinformationdesignlab.org, accessed November 20, 2010.

8. See http://benfry.com/isometricblocks.

9. See http://www.dunneandraby.co.uk/content/home.

10. See http://www.critical-art.net.

11. See http://www.appliedautonomy.com/isee.html.

12. For overviews of political posters and other forms of political graphic design, see Glaser and Ilic (2006), Lasn (2006), and McQuiston (1995). For an overview of the work of Krysztof Wodiczko, see Wodiczko (1999).

13. For overviews on Constructivism and the Bauhaus, see Fiedler and Feierabend (2008), Frampton (2007), Gropius (1965), James-Chakraborty (2006), Margolin (1998), and Rickey (1995).

Chapter 2

1. *State-Machine: Agency* is accessible at http://state-machine.org/agency, accessed August 22, 2011.

2. The *Naming Names* visualization is available at http://www.nytimes.com/ interactive/2007/12/15/us/politics/DEBATE.html, accessed August 22, 2011.

3. For a discussion of visualizations as a form of journalism, see Bogost, Ferrari, and Schweizer (2010).

4. *The Dumpster* is available at http://artport.whitney.org/commissions/ thedumpster, accessed August 22, 2011.

5. *We Feel Fine* is available at http://www.wefeelfine.org, accessed August 22, 2011.

6. The work of the design studio Stamen provides exceptional examples of interactive map products and services that weave together spatial data, photographs, and user-generated content and demonstrate the power of transcoding. In 2010, Stamen released two products *Polymaps* and *Prettymaps*, both of which enable designers and end-users to construct visually rich maps that integrate and display multiple forms of media content. See http://www.stamen.com, accessed August 22, 2011.

7. The CIA's *World Factbook* is available at https://www.cia.gov/library/publications/ the-world-factbook, accessed August 22, 2011.

8. The *Greenpeace Blacklist* is available at http://www.greenpeace.org/international/ en/campaigns/oceans/pirate-fishing/Blacklist1, accessed August 22, 2011.

9. For a comprehensive list of social network analysis software, see http://www .insna.org/software/index.html, maintained by the International Networks for Social Network Analysis, accessed August 22, 2011. For an overview of the technical approaches and issues to social network analysis, see Brandes and Erlebach (2005).

10. *They Rule* is available at http://www.theyrule.net, accessed August 22, 2011.

11. *Exxon Secrets* is available at http://www.exxonsecrets.org/maps.php, accessed August 22, 2011.

12. The music mashup is an extension of the remix toward something that is more like a composite. It still elides melding to the point of not recognizing or being able to separate the source materials, which characterizes the composite. One appealing characteristic of the music mashup is that it allows the recognition of the appropriation and application of a beat or lyric from one musician to another or strung together to make an entirely new third musical statement. Just as the remix was enabled with tools such as turntables, mixers, and tape decks, the mashup was enabled with digital audio tools. Software packages made possible two basic operations—beat matching between two songs, which allows the tempos to be integrated, and separating vocal from instrumental tracks through software equalizing. A simple recipe for making a mashup is to take one artist's track, remove the vocal, and then

place another artist's vocal on top of the first artist's track. Although the mashup scene has a rich and full history, it received popular attention with the 2004 release of *The Grey Album* by Danger Mouse, which layered a cappella vocals from rap artist Jay-Z's *The Black Album* over tracks from the Beatles' *The White Album* to produce a novel, conceptually compelling, aesthetically pleasing, and completely unauthorized and therefore illegal new hybrid album, which received critical acclaim as well as a cease-and-desist letter from EMI, holders of the copyright.

13. *Unfluence* is available at http://unfluence.primate.net, accessed November 19, 2011.

14. The Sunlight Foundation is a nonprofit organization that promotes government transparency and accountability by providing access to government-related data and application programming interfaces (APIs) for using that data.

15. Although the term *extension* can refer to any kind software application, it is most commonly used in reference to Web browser software.

16. *MAICgregator* is available at http://maicgregator.org, accessed August 22, 2011.

17. See http://maicgregator.org/FAQ, accessed August 22, 2011.

18. *Oil Standard* is available at http://turbulence.org/Works/oilstandard, accessed August 22, 2011.

19. For a discussion of how games operate only by playing extensions and how they relate to computational media more generally, see Bogost (2007).

20. *MAICgregator* does allow users to adjust the settings to undo that quality of seamlessness.

Chapter 3

1. See Herbert Simon (1996) as an example of a canonical text of classical artificial intelligence, which argues for intelligence as symbol manipulation. Debates concerning the relationship between symbol manipulation and computational intelligence arose early on in AI through the work of Hubert Dreyfus (1972) and later John Haugeland (1985) and were continued into 1990s in the field of science studies by Lucy Suchman (1987). For an overview of "nouvelle AI," see Rodney Brooks (1999).

2. For documentation of PARO, see http://www.pororobots.com, accessed October 18, 2010.

3. For a discussion of what the engineers and designers mean by "mental commitment robot," see http://www.paro.jp/english/about.html, accessed October 18, 2010.

4. This general theme is repeated throughout the research and marketing literature on PARO produced by the engineers and scientists at the National Institute of Advanced Industrial Science and Technology. For an argument of PARO as animal-like therapy, see Kaoru Inoue, Kazuyoshi Wada, and Yuku Ito (2008).

5. For a listing of publications on PARO, see http://www.pororobots.com/whitepapers.asp, accessed October 18, 2010.

6. Ibid.

7. For an overview of the marketing and public positioning of PARO, see http://www.parorobots.com, accessed October 18, 2010.

8. For an in-depth discussion, see Sherry Turkle (2011).

9. Phenomenology is a diverse field, and the treatment of embodiment is rigorous and nuanced, but in the phenomenological sense, embodiment refers to the fact that an entity has a body, and from that starting position, philosophical inquiries are made into the relations between the qualities of that body and a given entity's worldly capabilities and experience. In phenomenology, experience and the body are both sites of inquiry where terms and meanings are meted out. For example, for Maurice Merleau-Ponty (1962), the emphasis was not on a generic physiological body but rather on what he termed "the phenomenal body," which is a distinctive, individualized body that directs our relations with others (people and objects) in the world. For a discussion of phenomenology in relation to computational media and embodiment, see Paul Dourish (2001). For overviews of embodied cognition, see Andy Clark (1997), George Lakoff and Mark Johnson (1999), and Margaret Wilson (2002).

10. See Lucy Suchman's discussion of the work of the artist Stelarc (Suchman 2006, 241–258) and John Johnston (2008).

11. For documentation of *Blendie*, see Kelly Dobson (2007a) and http://web.media.mit.edu/~monster/blendie, accessed October 18, 2010.

12. Ibid.

13. Although Ernst Jenst first discussed the notion of the uncanny in his 1906 essay "On the Psychology of the Uncanny," Sigmund Freud's essay is the more common source for an explanation of the uncanny.

14. This film is a remake of *Chakushin Ari* (2003).

15. Given the limitations of robotics technology and the constraints of laboratory-based studies, research on the uncanny valley is challenging because it is difficult to construct a robot and a situation where an experience of the uncanny might be measured in a scientific manner. Nonetheless, within the field of human-robot interaction, there is a growing body of research on the topic. Examples include Michael L. Walters and colleagues (2008) and Chin-Chang Ho, Karl L. MacDorman, and Z. A. D. Dwi Pramono (2008).

16. For an overview of this move away from a singular focus on productivity and toward new themes in information and communication technology design, see William J. Mitchell, Alan S. Inouye, and Marjory S. Blumenthal (2003).

17. As specific examples, see Phoebe Sengers, Kirsten Boehner, Shay David, and Joseph Kaye (2005) and Sengers and Bill Gaver (2006).

18. For an overview of PaPeRo, see http://www.nec.co.jp/products/robot/en/index.html, accessed October 18, 2010.

19. For a detailed discussion of the design of *Omo*, see Dobson (2007a, 98–121).

20. For documentation of *Amy and Klara*, see http://www.realtechsupport.org/repository/male-dicta.html, accessed October 18, 2010.

21. Suchman (2006, 241–258) makes a similar observation concerning her encounter with the artist Stelarc's *Head*, which is a system consisting of a larger-than-life

projection of a three-dimensional virtual model of the artist's head and chat software that enables conversation between the prosthetic head and gallery visitors.

22. For in-depth descriptions of the text-to-speech software and the process of computationally constructing accents in *Amy and Klara*, see Böhlen (2006a, 2006b, 2008).

23. In this way, speech becomes available for what Bogost (2006, 3) calls "unit operations" or "modes of meaning-making that privilege discrete, disconnected actions."

Chapter 4

1. For documentation of the *Spore 1.1* project, see http://swamp.nu/projects/spore1, accessed November 22, 2010.

2. Although in 1991 this was a novel idea, today phones contain stunning computational capacities, and the idea of imbuing computation into objects other than the traditional computer seems obvious. But the vision of ubicomp espoused by Weiser and most contemporary researchers extends beyond smart phones by imbuing computation into all types of objects and environments.

3. In the project *Spore 1.1*, rather than having the computer disappear, its design explicitly brings the computer into view. The tree could have been housed in a large pot with opaque sides that would have kept the wires, fans, and circuit boards out of view. That much computer stuff is no longer needed to provide that functionality. A set of circuit boards that would occupy one-fifth the amount of space could now easily provide the same functionality. But the design of *Spore 1.1* is, or at least was, attention-grabbing because it showed a working vision of the near future that is both exploratory and explanatory of this notion of combing computation with everyday objects.

4. For marketing materials describing the Ambient Umbrella, see http://www.ambientdevices.com/products/umbrella.html, accessed November 22, 2010.

5. Consider the redesign of the British Petroleum logo. By using the glyph of the Greek *helios*, or sun, and a linguistic switch, in which *bp* is used as a stand-in for the phrase "Beyond Petroleum," the redesigned logo draws from and establishes questionable associations with environmentalism.

6. Many of these carbon footprint tools are related to advocacy. For example, the Nature Conservancy offers an online carbon calculator at http://www.nature.org/greenliving/carboncalculator. A similar calculator is offered by the United States Environmental Protection Agency at http://www.epa.gov/climatechange/emissions/ind_calculator.html. These calculators and countless others lead a user through a survey, collecting information on a range of topics from home heating and cooling to food and diet. From this information, the calculators generate both a carbon footprint record as well as suggestions for possible changes in behavior to lessen that footprint. All URLs accessed November 22, 2010.

7. For documentation of the *Natural Fuse* project, see http://www.haque.co.uk/naturalfuse.php, accessed November 22, 2010.

8. The value of the carbon offset is provided as a constant in the software—that is, it is a predetermined value.

9. For documentation of the *Ad-hoc Dark (roast) Network Travel Mug*, see http://survival.sentientcity.net/blog/?page_id=22, accessed November 22, 2010.

10. For discussions of the effects of contemporary technology on the changing character of cities, see Manuel Castells (2009), Stephen Graham and Simon Marvin (2001), and Saskia Sassen (2002).

11. For a collection of essays on urban informatics and urban computing, see Marcus Foth (2009).

12. For marketing materials describing the ShotSpotter Gunshot Location System, see http://www.shotspotter.com, accessed November 22, 2010.

13. For documentation of the *CCD-Me Not Umbrella*, see http://survival.sentientcity .net/blog/?page_id=17, accessed November 22, 2010.

Chapter 5

1. This does not mean that one would always go from information design to robots to ubiquitous computing. The tactics of adversarial design are not bound to any one category of objects, to any one quality, or even to the medium of computation. Each tactic was set with a genre and quality to create a resonant pairing that amplifies and gives clarity to the relations and affects, but they are not fixed to one another or mutually exclusive.

References

AIGA. 2008. "Design for Democracy." http://www.aiga.org/design-for-democracy.

Bender-deMoll, Skye, and Greg Michalec. 2007. *Unfluence.* http://unfluence.primate. net.

Bennett, Jane. 2010. *Vibrant Matter: A Political Ecology of Things.* Durham, NC: Duke University Press.

Bessette, Joseph. 1994. *The Mild Voice of Reason: Deliberative Democracy and American National Government.* Chicago: University of Chicago Press.

Björgvinsson, Erling, Pelle Ehn, and Per-Anders Hillgren. 2010. "Participatory Design and 'Democratizing Innovation.'" In *Proceedings of the 11th Biennial Participatory Design Conference* (PDC '10), 41–50. New York: ACM.

Bleeker, Julian. 2009. "Why Things Matter." In *The Object Reader,* edited by F. Candlin and R. Guins, 165–174. London: Routledge.

Bogost, Ian. 2006. *Unit Operations: An Approach to Videogame Criticism.* Cambridge: MIT Press.

Bogost, Ian. 2007. *Persuasive Games: The Expressive Power of Video Games.* Cambridge: MIT Press.

Bogost, Ian, Simon Ferrari, and Bobby Schweizer. 2010. *Newsgames: Journalism at Play.* Cambridge: MIT Press.

Böhlen, Marc. 2006a. *Amy and Klara.* http://www.realtechsupport.org/repository/ male-dicta.html.

Böhlen, Marc. 2006b. "When a Machine Picks a Fight." Paper read at CHI 2006, Workshop: Misuse and Abuse of Interactive Technologies, Montreal, April 22–27.

Böhlen, Marc. 2008. "Robots with Bad Accents." *Leonardo* 41 (3): 209–214.

Brandes, Ulrik, and Thomas Erlebach, eds. 2005. *Network Analysis: Methodological Foundations.* Berlin: Springer-Verlag.

Brooks, Rodney. 1990. "Elephants Don't Play Chess." *Robotics and Autonomous Systems* 6 (1–2): 3–15.

Brooks, Rodney. 1999. *Cambrian Intelligence: The Early History of the New AI.* Cambridge: MIT Press.

Buchanan, Richard. 2001. "Design and the New Rhetoric: Productive Arts in the Philosophy of Culture." *Philosophy and Rhetoric* 34 (3): 183–206.

Carlson, Max, and Ben Cerveny. 2005. *State-Machine: Agency.* http://state-machine .org.

Castells, Manuel. 2009. *The Rise of the Network Society.* Vol. 1 of *The Information Age: Economy, Society, and Culture.* West Sussex: Wiley-Blackwell. (Originally published in 1996.)

Clark, Andy. 1997. *Being There: Putting Brain, Body and World Together Again.* Cambridge: MIT Press.

Coles, Alex, ed. 2007. *Design and Art.* Edited by I. Blawick. Documents of Contemporary Art. Cambridge: MIT Press.

Corum, Jonathan, and Farhana Hossain. 2007. *Naming Names.* http://www .nytimes.com/interactive/2007/12/15/us/politics/DEBATE.htm.

Crang, Michael, and Stephen Graham. 2007. "Sentient Cities: Ambient Intelligence and the Politics of Urban Space." *Information Communication and Society* 10 (6): 789–817.

Critical Art Ensemble, with Beatriz da Costa and Claire Pentecost. 2002–2004. *Molecular Invasion.* http://www.critical-art.net/Biotech.html.

Dautenhahn, Kerstin, Bernard Ogden, and Tom Quick. 2002. "From Embodied to Socially Embedded Agents: Implication for Interaction-Aware Robots." *Cognitive Systems Research* 3: 397–428.

Deming, W. Edwards. 1993. *The New Economics for Industry, Government, Education.* Cambridge: MIT, Center for Advanced Engineering Study.

Dewey, John. 1954. *The Public and Its Problems.* Athens, OH: Swallow Press.

Dewey, John. 2008. *Logic: The Theory of Inquiry.* New York: Saerchinger Press.

Dobson, Kelly. 2007a. "Machine Therapy." PhD diss. Media Arts and Sciences, MIT, Cambridge.

Dobson, Kelly. 2007b. "Artist's Statement for 2007 VIDA Awards and Exhibition." http://www.fundacion.telefonica.com/es/at/vida/popUpPremiados/html/OMO-en .html.

Dobson, Kelly. 2008. "Machine Therapy," presentation at Pop Tech. http://poptech. org/popcasts/kelly_dobson__poptech_2008.

Dourish, Paul. 2001. *Where the Action Is: The Foundations of Embodied Interaction*. Cambridge: MIT Press.

Dreyfus, Hubert. 1972. *What Computers Can't Do: The Limits of Artificial Intelligence*. Cambridge: MIT Press.

Dunne, Anthony, and Fiona Raby. 2001. *Design Noir: The Secret Life of Electronic Objects*. Basel, Switzerland: Birkhauser.

Dunne, Anthony, and Fiona Raby. 2004. *Is This Your Future?* http://www .dunneandraby.co.uk/content/projects/68/0.

Dunne, Anthony, and Fiona Raby. 2007. *Technological Dreams Series: No.1, Robots*. http://www.dunneandraby.co.uk/content/projects/10/0.

Dunne, Anthony, and Fiona Raby. 1997. *Hertzian Tales 1994–1997*. http://www .dunneandraby.co.uk/content/projects/67/0.

Easterly, Douglas, and Matthew Kenyon. 2004. *Spore 1.1*. http://www.swamp.nu/ projects/spore1.

Elster, J., ed. 1988. *Deliberative Democracy*. Cambridge: Cambridge University Press.

Fiedler, Jeannine, and Peter Feierabend, eds. 2008. *Bauhaus*. Potsdam: Ullmann.

Foth, Marcus, ed. 2009. *Handbook of Research on Urban Informatics: The Practice and Promise of the Real-Time City*. Hershey, PA: Information Science Reference.

Frampton, Kenneth. 2007. *Modern Architecture: A Critical History*. London: Thames and Hudson.

Frank, Thomas. 2004. "Why Johnny Can't Dissent." In *Commodify Your Dissent*, edited by T. Frank, 31–45. New York: Norton.

Freud, Sigmund. 2003. *The Uncanny*. Translated by D. McLintock. London: Penguin Classics.

Friedberg, Jill, and Rick Rowley, dirs. 2000. *This Is What Democracy Looks Like*. Blank Stare Studio.

Fry, Ben. 2008. *Visualizing Data*. Sebastopol, CA: O'Reilly Media.

Fry, Ben. 2001a. *Chromosome 21*. http://benfry.com/chr21=icp.

Fry, Ben. 2001b. *Isometric Halotype Blocks*. http://benfry.com/isometricblocks.

Galloway, Alex. 2007. "Extension 4: Network." In *Processing: A Programming Handbook for Visual Designers and Artists*, edited by C. Raes and B. Fry, 563–578. Cambridge: MIT Press.

Garcia, David, and Geert Lovink. 1997. "The ABCs of Tactical Media." May 16. http://www.nettime.org.

Glaser, Milton, and Mirko Ilic. 2006. *The Design of Dissent: Socially and Politically Driven Graphics*. New York: Rockport.

Graham, Stephen, and Simon Marvin. 2001. *Splintering Urbanism: Networked Infrastructures, Technological Mobilities and the Urban Condition*. London: Routledge.

Gramsci, Antonio. 1971. *Selections from the Prison Notebooks*. New York: International Publishers.

Gropius, Walter. 1965. *The New Architecture and the Bauhaus*. Cambridge: MIT Press.

Habermas, Jürgen. 1989. *The Structural Transformation of the Public Sphere: An Inquiry into a Category of Bourgeois Society*. Cambridge: MIT Press.

Habermas, Jürgen. 1993. "Further Reflections on the Public Sphere." In *Habermas and the Public Sphere*, edited by Craig Calhoun, 421–461. Cambridge: MIT Press.

Habermas, Jürgen. 1996a. *Between Facts and Norms: Contributions to a Discourse Theory of Law and Democracy*. Cambridge: MIT Press.

Habermas, Jürgen. 1996b. "Three Normative Models of Democracy." In *Democracy and Difference*, edited by S. Benhabib, 21–30. Princeton, NJ: Princeton University Press.

Hall, Peter. 2008. "Critical Visualization." In *Design and the Elastic Mind*, edited by P. Antonelli, 120–131. New York: Museum of Modern Art.

Haque Design + Research. 2009. *Natural Fuse*. http://www.haque.co.uk/naturalfuse.php.

Harris, Jonathan, and Sep Kamvar. 2005. *We Feel Fine*. http://www.wefeelfine.org.

Haugeland, John. 1985. *Artificial Intelligence: The Very Idea*. Cambridge: MIT Press.

Hebdige, Dick. 1981. *Subculture: The Meaning of Style*. London: Routledge.

Hewitt, Jessica Friedman. 2008. "Case Study: AIGA Design for Democracy Develops Best Practices for Ballot and Polling Place Voter Information Material Design on Behalf of the U.S. Election Assistance Commission (September 2005–July 2007)." AIGA Design for Democracy. http://www.aiga.org/design-for-democracy.

Ho, Chin-Chang, Karl F. MacDorman, and Z. A. D. Dwi Pramono. 2008. "Human Emotion and the Uncanny Valley: A GLM, MDS, and Isomap Analysis of Robot Video Ratings." *Proceedings of the Third ACM/IEEE International Conference on Human-Robot Interaction*, 169–176. New York: ACM.

Honig, Bonnie. 1993. *Political Theory and the Displacement of Politics*. Ithaca, NY: Cornell University Press.

Inoue, Kaoru, Kazuyoshi Wada, and Yuko Ito. 2008. "Effective Application of Paro: Seal Type Robots for Disabled People in According to Ideas of Occupational Thera-

pists." In *Computers Helping People with Special Needs*, edited by K. Miesenberger, J. Klaus, W. Zagler, and A. Karshmer, 1321–1324. Berlin: Springer.

Institute for Applied Autonomy. 2001. *iSee*. http://www.appliedautonomy.com/isee .html.

James-Chakraborty, Kathleen. 2006. *Bauhaus Culture: From Weimar to the Cold War*. Minneapolis: University of Minnesota Press.

Jeremijenko, Natalie A. 2002–present. *Feral Robotic Dogs*. www.nyu.edu/projects/ xdesign/feralrobots.

Johnston, John. 2008. *The Allure of Machinic Life: Cybernetics, Artificial Life, and the New AI*. Cambridge: MIT Press.

Joerges, Bernward. 1999. "Do Politics Have Artefacts?" *Social Studies of Science* 29 (3): 411–431.

Knouf, Nicholas A. 2009. *MAICgregator*. http://maicgregator.org.

Kurgan, Laura. 2005. *Million Dollar Blocks*. Spatial Information Design Lab, Columbia University. http://www.spatialinformationdesignlab.org/projects.php?id=16.

Kurgan, Laura. 2008. "Design Heroix." Environmental Health Clinic Design Lecture series, April 13. New York.

Laclau, Ernesto, and Chantal Mouffe. 2001. *Hegemony and Socialist Strategy*. London: Verso. Originally published in 1985.

Lakoff, George, and Mark Johnson. 1999. *Philosophy in the Flesh: The Embodied Mind and Its Challenge to Western Thought*. New York: Basic Books.

Lasn, Kalle, ed. 2006. *Design Anarchy*. New York: ORO Editions.

Latour, Bruno. 2004. *Politics of Nature*. Cambridge: Harvard University Press.

Latour, Bruno. 2005. "From Realpolitik to Dingpolitik or How to Make Things Public." In *Making Things Public: Atmospheres of Democracy*, edited by B. Latour and P. Weibel, 14–41. Cambridge: MIT Press.

Lausen, Marcia. 2007. *Design for Democracy: Ballot and Election Design*. Chicago: University of Chicago Press.

Levin, Golan, Kamal Nigam, and Jonathan Feinberg. 2006. *The Dumpster*. http:// artport.whitney.org/commissions/thedumpster/credits.html.

Lupton, Ellen. 2006. *DIY: Design It Yourself*. New York: Princeton Architectural Press.

Mandiberg, Michael. 2006. *Oil Standard*. http://turbulence.org/Works/oilstandard.

Manovich, Lev. 2001. *The Language of New Media*. Cambridge: MIT Press.

Margolin, Victor. 1998. *The Struggle for Utopia: Rodchenko, Lissitzky, Moholy-Nagy, 1917–1946*. Chicago: University of Chicago Press.

McQuiston, Liz. 1995. *Graphic Agitation*. New York: Phaidon Press.

Merleau-Ponty, Maurice. 1962. *Phenomenology of Perception*. London: Routledge.

Mitchell, William J., Alan S. Inouye, and Marjory S. Blumenthal, eds. 2003. *Beyond Productivity: Information, Technology, Innovation, and Creativity, Committee on Information Technology and Creativity, National Research Council*. Washington, DC: National Academies Press.

Montfort, Nick, and Ian Bogost. 2009. *Racing the Beam: The Atari Video Computer System*. Cambridge: MIT Press.

Mori, Masahiro. 1970. "Bukimi No Tani." *Energy* 7 (4): 33–35.

Mouffe, Chantal. 2000a. *Deliberative Democracy or Agonistic Pluralism*. Vienna: Department of Political Science, Institute for Advanced Studies (IHS).

Mouffe, Chantal. 2000b. *The Democratic Paradox*. London: Verso.

Mouffe, Chantal. 2005a. *On the Political (Thinking in Action)*. New York: Routledge.

Mouffe, Chantal. 2005b. "Some Reflections on an Agonistic Approach to the Public." In *Making Things Public: Atmospheres of Democracy*, edited by B. Latour and P. Weibel, 804–807. Cambridge: MIT Press.

Mouffe, Chantal. 2007. "Artistic Activism and Agonistic Spaces 2007." *Art and Research* 2 (1). http://www.artandresearch.org.uk/v1n2/mouffe.html.

Murray, Janet. 1997. *Hamlet on the Holodeck*. Cambridge: MIT Press.

Norman, Donald. 2010. "Why Design Education Must Change." *Core77*, November 26. http://core77.com/blog/columns/why_design_education_must_change_17993.asp.

On, Josh. 2001, 2004, 2011. *They Rule*. http://www.theyrule.net/2004/tr2.php.

On, Josh. 2004. *Exxon Secrets*. http://www.exxonsecrets.org/maps.php.

Oxford English Dictionary (OED) Online. 2008. "agon." http://oed.com/public/redirect/welcome-to-the-new-oed-online.

PARO Robotics U.S., Inc. 2008. "PARO Robots U.S. Inc. Brings Hi-Tech Friends to Life." http://www.parorobots.com/pdf/pressreleases/PARO%20Robots%20US-Press%20Release%202008-11-20.pdf.

Picard, Rosalind. 2000. *Affective Computing*. Cambridge: MIT Press.

Picard, Rosalind. 2005. *Affective Computing*. http://affect.media.mit.edu.

Raley, Rita. 2009. *Tactical Media*. Minneapolis: University of Minnesota.

Rawls, J. 1971. *A Theory of Justice.* Cambridge: Harvard University Press.

Rawls, J. 1993. *Political Liberalism.* New York: Columbia University Press.

Rickey, George. 1995. *Constructivism: Origins and Evolution.* New York: George Braziller.

Sack, Warren. 2004. *Agonistics: A Language Game.* http://artport.whitney.org/gatepages/artists/sack.

Sassen, Saskia, ed. 2002. *Global Networks, Linked Cities.* London: Routledge.

Schmitt, Carl. 1996. *The Concept of the Political.* Translated by G. Schwab. Chicago: University of Chicago Press.

Sengers, Phoebe, Kirsten Boehner, Shay David, and Joseph Kaye. 2005. "Reflective Design." In *Proceedings of the Fourth Decennial Conference on Critical Computing, Aarhus, Denmark, August 20–24,* edited by Olav W. Bertelsen et al., 49–58. Aarhus, Denmark: University of Aarhus.

Sengers, Phoebe, and Bill Gaver. 2006. "Staying Open to Interpretation: Engaging Multiple Meanings in Design and Evaluation." In *Proceedings of the Sixth Conference on Designing Interactive Systems, University Park, PA,* 99–108. New York: ACM.

Shepard, Mark. 2009a. *Ad-hoc Dark (roast) Network Travel Mug.* http://survival.sentientcity.net/blog/?page_id=22.

Shepard, Mark. 2009b. *CCD-Me Not Umbrella.* http://survival.sentientcity.net/blog/?page_id=17.

Shepard, Mark. 2009c. *Sentient City Survival Kit.* http://survival.sentientcity.net.

Simon, Herbert. 1996. *The Sciences of the Artificial.* Cambridge: MIT Press. Originally published in 1969.

Smith, Anna Marie. 1998. *Laclau and Mouffe: The Radical Democratic Imaginary.* London: Routledge.

Strauss, Anselm. 1988. "The Articulation of Project Work: An Organizational Process." *Sociological Quarterly* 29 (2): 163–178.

Strauss, Anselm. 1993. *Continual Permutations of Actions.* New York: Aldine de Gruyter.

Suchman, Lucy. 1987. *Plans and Situated Actions: The Problem of Human-Machine Communication.* Cambridge: Cambridge University Press.

Suchman, Lucy. 2006. *Human-Machine Reconfigurations: Plans and Situated Actions.* Cambridge: Cambridge University Press.

Turkle, Sherry. 2006. "A Nascent Robotics Culture: New Complicities for Companionship." AAAI Technical Report Series, July. Association for the Advancement of Artificial Intelligence, Menlo Park, CA.

Turkle, Sherry. 2011. *Alone Together: Why We Expect More from Technology and Less from Each Other.* New York: Basic Books.

Walters, Michael L., Dag S. Syrdal, Kerstin Dautenhahn, René T. Boekhorst, and Kheng L. Koay. 2008. "Avoiding the Uncanny Valley: Robot Appearance, Personality and Consistency of Behavior in an Attention-Seeking Home Scenario for a Robot Companion." *Autonomous Robots* 24 (2): 159–178.

Weiser, Mark. 1991. "The Computer for the 21st Century." *Scientific American* 265 (3) (September): 94–104.

Wilson, Margaret. 2002. "Six Views on Embodied Cognition." *Psychonomic Bulletin and Review* 9 (4): 625–636.

Winner, Langdon. 1980. "Do Artifacts Have Politics?" *Daedalus* 109 (1): 121–136.

Wodiczko, Krzysztof. 1999. *Critical Vehicles: Writings, Projects, Interviews.* Cambridge: MIT Press.

Index